SOUNDINGS

CROSS CHANNEL

PHOTOGRAPHIC MISSION

Kenneth Baird Simone Canetty-Clarke Huw Davies Anna Fox Julian Germain

Malcolm Glover Peter Kennard Karen Knorr Patrick Sutherland Paul Trevor Janine Wiedel

SOUNDINGS

Introduction by Neal Ascherson

Edited by Jane Alison and Brigitte Lardinois

1994

ACKNOWLEDGEMENTS

Published in May 1994 in an edition of 2,000 copies
on the occasion of the official Channel Tunnel opening
Copyright © 1994 Cross Channel Photographic Mission
and the authors
Copyright in photographs remains with
the individual photographers

ISBN 0 9517427 5 2

All works commissioned by the

C·C·P·M

CROSS CHANNEL PHOTOGRAPHIC MISSION
Mission Photographique Transmanche

c/o Arts Promotion
County Hall, Maidstone, Kent ME14 1XQ

This book has been funded solely by South East Arts

SOUTH·EAST ARTS

South East Arts,
Kent County Council Arts and Libraries Department
and East Sussex County Council
have wholly or partially funded all the CCPM commissions

Photographs of works by Julian Germain:
Matthew Chattle p.35, Mike Parsons pp.36–39
French translation by Lucia Hollis

Printed in Great Britain by
Balding + Mansell, Wisbech
Typeset by Goodfellow & Egan, Cambridge
Designed by Richard Hollis

Distributed by Lund Humphries
Park House, 1 Russell Gardens
London NW11 9NN

Since the Cross Channel Photographic Mission was established in 1987 a very large number of people inside and outside the photographic community have helped in all sorts of ways to sustain the project and enable it to develop. This book is evidence of what has been achieved with their support. The CCPM is extremely grateful to all of them, and in particular to the South East Arts Board, Kent County Council Arts and Libraries Department and East Sussex County Council who between them have provided guidance and most of the financial and 'in kind' support for its work.

Without the imagination, perseverance, skill and understanding of the commissioned photographers, however, nothing would have been achieved. The CCPM is greatly indebted to them all for their contributions.

Three of the CCPM commissions were brought about through a collaboration with art galleries in the South East Arts region – Dover Museum, Hove Museum and Art Gallery and the Towner Art Gallery and Museum, Eastbourne. The CCPM is most grateful to them for their help and curatorial expertise.

Additional assistance in cash or kind for commissions was provided by Ashford Borough Council, the Countryside Commission, Dover District Council, Eurotunnel, Hoverspeed and Worthing Museum and Art Gallery. Again, the CCPM is most grateful for their support.

Thanks must also go to our French colleagues. To Pierre Devin at the Centre Régional de la Photographie, Nord Pas-de-Calais who, with Morris Newcombe of the erstwhile Photogallery, St Leonard's-on-Sea, conceived the idea of the cross-Channel collaboration, and to the staff of the Maison Pour Tous, Calais, who through their unfailing helpfulness further encouraged cross-Channel links.

Finally, the CCPM would like to thank Neal Ascherson, who responded with such alacrity and generosity when invited to write an essay for this book. A deep debt of gratitude is also owed to Jane Alison and Brigitte Lardinois for the considerable empathy they demonstrated towards the work of the commissioned photographers and the aims of the CCPM when they undertook the challenging task of organising the editing and publishing of the book. They and designer Richard Hollis enhanced the project with their high level of skill and unruffled good humour.

Cross Channel Photographic Mission

CONTENTS

CROSS CHANNEL PHOTOGRAPHIC MISSION

The Channel Tunnel represents a breach of the physical barrier which has separated Britain from the Continent for 12,000 years. As a transport link, it ties Britain firmly and symbolically to the Single European Market and will remain a monument to modern technology and international capital. However, these developments did not go unchallenged. Many felt that national identity was threatened, that the environmental damage was not worth the price, that Britain would lose its independence and that the Garden of England should be preserved at all costs.

The Cross Channel Photographic Mission (CCPM) and the parallel French project, La Mission Photographique Transmanche, both originated from a border region of Europe at a time of rapid change. The photographic commissions illustrated in this book stem from the British side and all took place during the construction of the fixed link between South East England and Northern France. Their publication coincides with the opening of the Tunnel in May 1994.

The CCPM (a collaborative project involving South East Arts, Kent County Council and East Sussex County Council, as well as our French partners) encouraged photographers to play a part in the debate by recording and interpreting the people, places and issues involved in this time of change.

From the outset the CCPM has sought to increase audiences for photogaphy. To this end it has exhibited the photography it has commissioned as widely as possible whilst at the same time nurturing local involvement through educational and other community initiatives.

In 1987, when the CCPM was first conceived, a sharp contrast existed between, on the English side, a Garden of England threatened by an overheated economy in the South East generally, and 'la crise de la région' in Nord Pas de Calais where the run-down of heavy industry had resulted in high unemployment. The construction of the Tunnel was seen by the French as a positive development, while many in Britain saw it as a threat. Attitudes to cultural provision and hence the levels of funding made available (sometimes ten times greater on the French side) mirrored these differences. By 1994, however, there had been long-running recessions affecting life on both sides of the Channel, with a consequent decline in optimism about the European ideal.

By the time the Tunnel opens a total of twenty-four commissions will have been completed, twelve on each side. Audiences will now be able to judge how successful photographers on both sides of the Channel have been in interpreting the changes taking place in the closing years of the 20th century. Meanwhile, the CCPM continues to commission photographers.

Le tunnel sous la Manche constitue une brèche dans la barrière naturelle qui a séparé pendant 12 000 ans la Grande-Bretagne du continent. Cette voie de transport lie fermement et symboliquement la Grande-Bretagne au Marché Unique Européen; elle consacre la technologie moderne et s'inscrit dans le patrimoine international. Pourtant, ces aménagements ont provoqué bien des controverses. Nombreux sont ceux qui ont cru que leur identité nationale serait menacée et que les dégâts causés à l'environnement étaient un prix bien trop cher à payer. Ils craignaient de perdre leur indépendance et voulaient protéger par tous les moyens le 'Garden of England', comté du Kent.

La Cross Channel Photographic Mission (CCPM) et son pendant français, la Mission Photographique Transmanche, sont toutes deux apparues dans une région frontalière d'Europe à une époque de changements rapides. Les séries d'épreuves illustrant cet ouvrage sont le fruit du travail de photographes anglais et furent toutes réalisées pendant la construction de la liaison transmanche entre le sud-est de l'Angleterre et le nord de la France. Leur publication coincide avec l'inauguration du tunnel, en mai 1994.

La CCPM (un projet mené en collaboration avec South East Arts, les conseils régionaux du Kent et du Sussex et nos partenaires français) a encouragé les photographes à prendre part au débat en immortalisant – tout en intégrant leur propre interprétation – les hommes, les lieux et les problèmes soulevés, qui ont marqué cette période de changements.

Dès le début de son action, la CCPM a cherché à promouvoir le travail des photographes auprès d'un public de plus en plus large. Dans ce but, elle a exposé le plus souvent possible les photographies commandées, tout en incitant le grand public à participer au projet par le biais d'initiatives pédagogiques et socio-éducatives.

En 1987, à l'époque de la création de la CCPM, un contraste marqué existait entre, du coté anglais, un 'Garden of England' menacé par une économie fiévreuse dans l'ensemble du comté et 'la crise de la région' du Nord Pas-de-Calais où le déclin de l'industrie lourde avait entraîné un fort taux de chômage. La construction du tunnel était vue d'un bon oeil par les Français mais considérée comme une menace par la plupart des Anglais. Les attitudes adoptées par chacune des nations vis à vis des ressources culturelles et par conséquent le montant des fonds engagés reflétaient ces différences de point de vue. Mais depuis lors, les populations des deux cotés du tunnel ont connu une longue période de récession et leur foi en l'idéal européen s'est émoussé.

Avant même l'ouverture du tunnel, un total de vingt quatre séries de clichés, douze séries par pays, sera achevé. Après avoir pris connaissance des douze publications françaises, le public sera en mesure d'apprécier le talent avec lequel l'ensemble de ces photographes ont su interpréter les changements s'opérant durant cette fin de siècle. En attendant, la CCPM continue de commissionner les photographes.

Janine Wiedel
Dover:
The White Cliffs
Triathlon

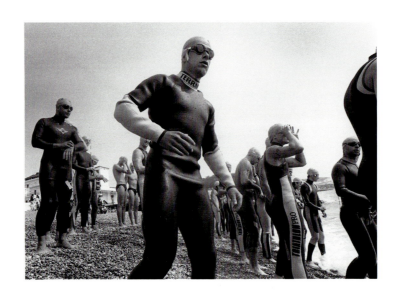

PREFACE

Ken Baird's 'Sound Mirror' high on Abbot's Cliff can read as a symbol for this book and the work of the CCPM. Powerful and strangely beautiful, this listening device once stood proud against the possibility of alien invasion on England's border with Europe. In its redundant state, its beauty is enhanced by the wearing of years and its quiet obsolescence. Now it may stand for something else – a responsiveness, a willingness to listen and to change.

The book's title, *Soundings*, reflects the open, but at the same time probing nature of enquiry which is a mark both of the work of the photographers and the spirit of the Cross Channel Photographic Mission itself. For the most part, the CCPM has given the photographers a welcome free hand to develop their brief in a way which they felt was most appropriate and offered the greatest freedom to extend their own practice. It has actively encouraged diverse approaches to photography and also in commissioning work of poetry and prose it has allowed different voices to emerge.

Out of this broad range of work, previously and concurrently brought together in different forms as exhibitions, our task was to shape the images afresh to create a new and coherent whole. It became apparent at an early stage that each body of work should stand alone and have its own character within a larger design framework that would both contain and allow for this divergence.

The book opens with an England unfolding before our eyes. A great sweep of English history, and the present day scarification by roads, railways, pylons and the like, are interwoven in Ken Baird's opening images. His viewpoint, whether airborne or on the land, is that of the traveller who maps out the terrain which is then covered by the other photographers and us, the viewers. As a counter to his images of fortification and defence – a history of an Island Britain – the book concludes with Karen Knorr's study of the dialogue for equality between the sexes and peoples.

For most of the photographers the focus has been on Kent and its fringes, those areas most tangibly affected by the Tunnel. But this emphasis on a particular locality does not mask the fact that the images are about who we all are and what kind of society we live in. What emerges in *Soundings* is a contemporary archaeology – a picturing of the marks people make on the land as they cross it, the houses and monuments they build, the experience of their life as written in a face or a gesture.

We should like to acknowledge the very considerable contributions of Richard Hollis and Neal Ascherson, as well as the invaluable support and encouragement of Leo Stable and Anne MacNeill of the Cross Channel Photographic Mission.

We are grateful to the funders of this project for the trust they have put in us and, last but not least, we would like to thank the photographers, each and every one of whom was co-operative and open to our suggestions. We hope this book does justice to their work and to the aims of the Cross Channel Photographic Mission.

Jane Alison
Brigitte Lardinois

Kenneth Baird
Entrance to the Channel Tunnel
under construction:
Sugarloaf Hill

10

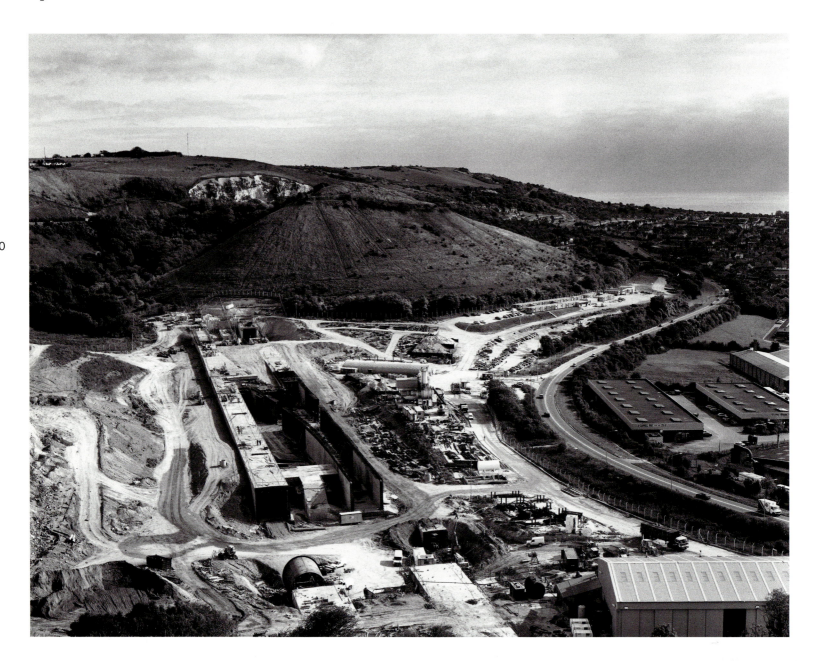

Neal Ascherson

THE UNDERMINING OF BRITAIN

To join two countries by a tunnel is a feat of engineering, but also of the imagination. As such, it raises visions and provokes reactions which tell many stories and reveal a great deal about the underlying hopes and fears of those who are to be joined.

Precedents are rare. In the nineteenth century, when the great Alpine tunnels were projected, the Swiss balanced all the commercial advantages against a possible threat to their liberty and independence. They concluded that the risk was worth taking, in contrast to the British who, during the Victorian debates over Channel tunnels took a strictly military view. The film-maker Georg Pabst, in *Kameradschaft* (1931), imagined French and German coal-mines whose galleries connected, and made this theme into a tremendous fable about working-class internationalism and solidarity (in a mine disaster) which transcended all the petty divisions and frontier-fences on the surface a mile above. More recently, the two German states, now one, were connected repeatedly by clandestine tunnels; some dug by desperate fugitives from the East, others constructed by professional *Fluchthelfer* who charged refugees enormous sums in dollars to use their escape-hole, or excavated by intelligence services probing for one another's telephone cables. All these tunnels were associated with optimism in one form or another. It was thought that they would allow a free flow of international understanding, or access to liberty, or simply an increase of information.

An international tunnel, then, is in several senses of the word an undermining. It digs under an obstacle: a mountain range, frontier wall or Channel. But it has also been constantly perceived as the undermining of some established order. Most of the examples I have quoted were founded on the assumption that the existing order was in some way obsolete or undesirable and deserved to be undermined. Progress and commerce had rendered the road passage over the Swiss passes intolerably slow and unreliable. Pabst thought that nation-states deserved to be undermined by the international proletariat. The Berliners burrowed under the Wall as a preliminary to overthrowing it.

This is why the British reaction to the opening of a tunnel under the Channel and its direct rail link between Britain and France is so curious. It is above all a valediction. Something is being undermined here, for good, but the British public imagination is clearly not sure that it wants to lose that something. People visit the route of the rail link across Kent as if to visit a dying relative – to say goodbye to an aspect of England, to see and appreciate it for one last time. Most of these melancholy tourists seem to accept the necessity of the Tunnel, but they are touched by a sense that the loss – that which is to be undermined and overcome – is grievous. England will not be the same again, and they are not certain that England joined directly to France will be a better place.

Many of the artists who contributed to the Cross Channel Photographic Mission have picked up this all-permeating flavour of regret (a flavour almost completely absent in the

regions of France affected by the Tunnel). So what is being lost here, and what is being mourned?

The first loss, plainly, is a strip of physical environment, either removed by the Tunnel and the rail route or deformed out of recognition by proximity to them. The damage along this strip, in the context of south-eastern England as a whole, is going to be severe but it would be an exaggeration to call it overwhelming. As far as existing buildings and landscape are concerned, the impact will be heavy on several pretty Kentish villages – parts of which will be rendered barely habitable by construction and permanent train noise – and in spite of the latest proposals for increasing the proportion of track enclosed in tunnels, the North Downs will inevitably suffer scarring. But comparison to what happened in the nineteenth century is instructive. There were two rival railway companies in the 1840s which built lines from the capital to the Channel: the London, Chatham and Dover Railway running out of Blackfriars Station in London and the East Kent Railway which began originally at Rochester. The two companies left a track of ruthless devastation across Kent as their armies of labourers, equipped with little more than picks, shovels and manually-operated tip-trucks, drove straight lines across the county. The route taken by the London, Chatham and Dover teams did the worst damage; it ran parallel to the North Downs across the plain between the Downs and the Thames estuary, across a region which had been densely populated since the Iron Age, ripping through the Saxon and mediaeval centres of one town after another. The loss to history was, in retrospect, horrifying. In between the towns of Kent, the navvies dug their way through Palaeolithic gravel-beds, Roman villas, Iron Age field-patterns and Saxon cemeteries. From time to time, local antiquaries were able to buy back the odd relic from the railway labourers. But all too often, as the early volumes of *Archaeologia Cantiana* record, it was a matter of encouraging them to remember what they had already sold, smashed or thrown away: a 'pipkin' of 'old pennies' (i.e. a coin hoard, probably Belgic or Romano-British), or a mysterious cubical 'coffin' of black oak beams supposed to have contained 'clay pots' and ashes (a burial? part of a Bronze Age cargo boat?).

Yet that loss – though resented by the denizens of cathedral closes and by enlightened landowners – was generally held to have been a price well worth paying for railways to the Channel ports. Omelettes required broken eggs, and progress had its cost. Such was the self-confidence of Victorian Britain. In the 1990s, by contrast, a far smaller loss to the appearance, monuments and archaeological potential of Kent is held to be almost intolerable. The corresponding addition to human happiness offered by the Tunnel may just outweigh that loss, in majority opinion, but it is evident that for many it will not.

In any case, that sort of calculus is out of date. We are beginning to realise how deeply Victorian it is to think that decisions – especially vast decisions like the Tunnel and railway project – are made on a simple profit-and-loss matrix, like a village butcher's cashbook. Our fathers and mothers might still have approached choices – a marriage, a purchase, a career option – in this way, by taking a sheet of paper and filling in two ink columns headed 'pro' and 'con'. Until very recently, this has seemed the most rational of procedures. But now, as the whole assessment procedure for the Tunnel and the rail link has shown, responsible people are growing wary of Benthamite arithmetic about pluses and minuses of pleasure or pain. Volume after volume of environmental assessment has been published, estimating in painstaking detail what the Union Railway track will do to this historic woodland, this scheduled ancient monument, this group of seventeenth-century farm buildings or this open prospect over downland. And yet, significantly, nowhere is there a profit-and-loss judgement – not even a page of propaganda hinting that the high-speed Channel crossing is 'worth' the destruction of places of 'low moderate concern'. The judgement will be made elsewhere. And it will not be made by 'pro' versus 'con', but by an almost soldierly appreciation of a battlefield. Here advances the Union Railway, towards (let's say) the River Medway. But there across its path stand an Area of Outstanding Natural Beauty (AONB), several Sites of Special Scientific Interest (SSSI) and squadrons of Special Landscape Areas (SLA). The question for the railway's generals is simply this: are we strong enough to break through them, and what losses (money, time, diversions) might a breakthrough cost?

Decisions now are a calculation about power, not about benefit. Those who wanted the Tunnel thought that it would be good for them, believed that the country could be

persuaded that it would be good for Britain too, and then settled down to estimating whether they could overcome the strength of the entrenched lobbies which they knew would oppose them. In the same way, the most dedicated protestors – those who believe that in defending the landscape of Kent they are defending the whole 'natural heritage' of the nation – are not prepared to play the profit-and-loss game.

Damage to this landscape, they would say, is something absolute. They argue that it is irrelevant and meaningless to tot up damage against possible social benefit. Sums like that are utterly subjective, and will be added up differently by different generations. What was an acceptable loss to the Victorians – a Bronze Age barrow dug away, a wood recorded in Domesday Book felled for railway cutting – now appears an unpardonable cultural crime. The loss itself, on the other hand, is not subjective in any way, but all too real. A thousand-year oak which is cut down stays down.

To explore the route of the rail link between Folkestone and the Thames crossing is to begin to understand this strain of 'absolutism' in the opposition. Two things become clear. The first is that the impact of the new rail route on the Kentish landscape will not, after all, be catastrophic (there are a few places in which it will be very serious, but no worse). The second discovery, however, is that the route is littered from the Thames to the sea with evidence of the failure of the 'pro and con' style of argument in the past.

Between the nineteenth and late twentieth century, the impact of railways and then roads along the southward face of the North Downs – the route of the Channel Tunnel link – has been enormous. The railways broke open what were until then backward and impoverished communities; in the village church at Harrietsham, you can read in the memoirs of a Victorian vicar's wife how violent and isolated the place was, regularly cut off by mud and snow from the outside world until the railway arrived in the 1880s. A 'pro' in terms of social improvement, but at a cost – the railway was laid slap through the ancient village nucleus and it is still there, and just as noisy, while Harrietsham's poverty is not even a memory. And the defilement wrought by railways is nothing compared to the effect of new roads, above all in the last twenty years or so. The 'pro' is presumably faster road journeys between Ashford and Maidstone. But the improved A20 cuts Harrietsham off from its natural hinterland of little fields and orchards on the other side of the road and slices in two the village of Charing, whose companionable main street has become a mortally dangerous traffic torrent.

The ruthless 'landtake' of new roads is a loss which can never be made good. It does not impress the objectors that the additional impact of the Tunnel link will be marginal, but it is none the less true. Just north-east of Maidstone, in a once-beautiful lap of country between the Down crest at Blue Bell Hill and the River Medway, the disturbance caused by the new railway will be minor compared to the devastation of the new motorway interchange under construction near Aylesford, or to the ranks of smoking industrial chimneys along the far bank of the river. But those who protest have seen how wrong the calculations of all previous planners went. They are not interested in matching greater environmental damage against lesser. They simply say 'No'. From Blue Bell Hill, it is possible to see what they mean.

At Kit's Coty House and Little Kit's Coty (two majestic 'menhir'-type assemblages of stone slabs which are the remains of Neolithic burial chambers), the alignment of the new railway has been changed several times and eventually buried in a tunnel to avoid disturbing the 'setting' of the monuments and disruption to the old Pilgrim's Way, running along the ridge of the North Downs to Canterbury. This almost obsequious respect to the environment contrasts with the irreparable damage done on the same shoulder of the Downs by road up-grading, especially by the huge new motorway link from Maidstone to Gillingham which dominates the physical landscape with its scarring and has simply eradicated a whole stretch of the Pilgrim's Way. The M20, further east, has transformed a fifteen-mile stretch of Kent countryside under the Downs into a confined traffic corridor between hills and motorway. Here again, the new rail alignment which runs parallel to the motorway is only reinforcing an older intrusion.

So people's sense of loss is not primarily about the physical environment. Rather, it is the feeling that we will no longer be living on an island. This is essentially an English perception; the Scots and the Welsh, understanding themselves as small, peripheral European nationalities, do not worry about it. But

English identity, the spirit of the British state, has been built up around the idea of isolation and difference. Obviously, this was not always true. In the late Iron Age, south-eastern England formed some kind of loose cultural whole with Celtic kingdoms in northern France. Then came the incorporation of the Britannia province into the Roman Empire, and much later the cross-channel political links of the Norman kingdom and the Anglo-French mediaeval polity which included south-western France. The 'island identity' was really established in the Tudor period, as England was given an imperial, maritime destiny pointing outwards and westwards. John Dee, the wizard and con-man from Wales, persuaded Elizabeth that the Tudors, with their Welsh origins, were the reincarnation of the Ancient British empire of Arthur, which once – supposedly – ruled over all England and Wales before the coming of the Saxons. Elizabeth was therefore the heir to Arthur's mythical overseas empire, an idea confected out of the legends that Prince Madoc had once sailed to America and colonised it, long before the discoveries of Columbus, and the Welsh-inspired theory (which was not finally extinguished until the nineteenth century) that the languages of the indigenous Americans were really a variant of Welsh.

Most nations have to be forged, in both senses of the word. The Arthurian forgery, or myth of origin, served to authenticate the beginnings of the first Anglo-British empire and the turning-away from continental Europe which had begun earlier in the sixteenth century with the Henrician Reformation and the break with Rome. The defence of the Channel barrier, for the next three centuries at least, was understood as the defence of a moral as well as a physical and political frontier: 'across there' were powers, French and Habsburg above all, whose agenda was to impose an alien religion and an absolutist form of government upon England/Britain.

Behind the sea frontier, the British state continued to diverge from European patterns. The first European political revolution – the English Civil War – ended with the 1689 settlement which merely took the doctrine of absolutism away from the monarch and transferred it to Parliament. In consequence, the politics of the Enlightenment and the French and American Revolutions missed Britain almost entirely. The republican

project, which means the doctrine of popular sovereignty and the supremacy of a written constitution incorporating individual human rights, did not change the archaic British philosophy of state which has lasted, little modified, from 1689 to today.

Socially, the two sides of the Channel grew steadily further apart. For nearly two centuries, cross-Channel travellers have been intrigued by the visual difference between Kent and the French departments just across the water. The geological structure is much the same: a continuation of the chalk downs which formed a bridge until the sea broke through sometime in the Mesolithic period. But the territory south of Calais or Boulogne is an open, un-hedged country of peasant strips and large villages. Kent, in contrast, is an English patchwork of small hedged-off fields, with a denser population which lived – until recently – mostly in a few large towns or in isolated farms; the villages were generally small. One nation had remained more or less feudal and unimproved agriculturally until the Revolution, when the land was broken up and distributed as the private property of small peasants. Across the water, by contrast, the Enclosure movement and the spread of middle-class wealth had already produced a landscape of hedged fields in which capitalist farmers employed landless labourers.

There was another difference. The Calais region, though agriculturally poor, was close to one of the great industrial basins of Europe: the coal, iron and textile cities which spanned the Franco-Belgian border. Northern France was close to the centre of things, economically. Kent, in contrast, had become a backwater. There were collieries, clustered in the north of the county in a single coalfield, and there were shipyards and dockyards on the Medway. But by the nineteenth century, rural Kent was part of the general backwardness which afflicted most of southern England. The centres of development and prosperity were almost all north of London; the rural south was notorious for ignorance, low living standards, apathy and bad roads. The proximity of London itself meant little to Kent, beyond the arrival of rich businessmen who purchased country estates or the use of East End seasonal labour in the hopfields. Most significantly, the presence of the Channel did little to help Kent. Maritime trade

went overwhelmingly through Liverpool, Bristol, Glasgow, Ipswich and the port of London itself; imports and exports through Dover or Folkestone were small stuff, and those towns never grew into great commercial cities or developed an industrial hinterland. The Kent coast had been for centuries the site of fortifications, naval bases and barracks but, with the exception of the great naval dockyard at Chatham, Kent's strategic importance made little impact inland. Even the transit passenger and mail traffic between London and Dover, bound to and from France, did not create any corridor of prosperity until the building of the railways. It was not large, in the sense that little of it was bulk goods, and the overflow of cash from it stayed either with the customs at Dover or with the innkeepers and stable-owners along the Dover road.

Kent's location at the Channel narrows, in short, did little or nothing to help it. Once, in the distant past, this position had drawn Kent strongly into the European mainstream. Later, as the English state developed, it had exactly the opposite effect: to isolate the county as a relatively under-developed peninsula on the periphery, just as if Kent had faced some limitless ocean instead of the visible shores of the European mainland. When some prosperity did reach the area in the nineteenth century, it was largely confined to cash-crop agriculture in West Kent: hops and berries for domestic consumption rather than for export. Ashford became a railway town, Canterbury began to attract mass tourism and the improvement of steamers at last began to multiply cross-Channel passenger traffic through the ports. But even today, at the end of a half-century which has seen the whole base of British wealth-creation shift from the North into the South-East of England, East Kent remains a basically rural place, its population inflated by hundreds of thousands of long-range London commuters but its back still turned to the Channel.

The story of Kent is an example of 'islandism' and its consequences. Looked at in practical terms, a re-connection of this part of England into the Continental economy promises all gain and no loss. But this sense of loss is not about practicalities. Kent is already part of a Euro-region which crosses the Channel, so that it has ties with Flanders which it does not have with – say – Essex. But few people know or care about this. What they mind about is the fear that by 'joining the Continent', England will become less English. Something special, something islanded-off from the harshness of the rest of the world, will leak invisibly away down the Chunnel.

This is worse than superstitious – it is misleading. Englishness, however we define that, is not at risk. The English will not become less English by the physical fact that traffic to the Continent passes under the water rather than over it. Neither is 'Anglitude' menaced by the social-political consequences of European union, because it is an infinitely flexible description. What is at risk here is not a nation but a state. The Channel tunnel does mean that England will become less British.

The British State is an artefact, as are all states, but this one was made at the end of the seventeenth century. Its foundations were the principles of authority and modified absolutism. Its orientation was away from Continental Europe and towards the oceans. English in design and spirit, it soon incorporated Scotland by guile and already possessed Ireland through force. This artefact has been repeatedly redecorated and repaired, with all kinds of small modernisations but in outline the old structure is still with us. Yet this state, through a series of decisions over the last thirty-five years, has committed itself to forming part of a united Europe.

The member-states of the European Union, and indeed the central apparatus of the Community or Union itself, belong to the Enlightenment tradition. They have long ago abandoned the old idea of absolute national sovereignty, and adopted the idea that a written supreme law stands above all parliaments, rulers or supranational associations. But this conflicts with British constitutional doctrine which, for example, cannot allow that any decision by any person or body is immune to being overthrown by the House of Commons – by a majority of one or more. It conflicts directly with a state doctrine which holds that official information is a state monopoly: everything is by nature secret, except that ministers may from time to time agree to allow the public access to that information. It declares a 'rights culture', incompatible with the British reliance upon authority tempered by humanity and common sense. It proclaims that state sovereignty can be broken up and distributed, as to the states of a federation whose laws, in certain cases, cannot be overruled by the central government.

This principle, flagrantly denying the absolute and indivisible sovereignty of Parliament, cannot be applied by the British state – which is why Irish Home Rule was rejected by Parliament in 1886, and why blood has been flowing more or less ever since.

This is the special nature of Britishness. As European Union becomes more real and as – year by year – Britain in practice participates in 'federal' institutions at a European level, this artefact will begin to disappear. Obsolete, a relic of history, it is not compatible with the design of modern citizenship which the Union is elaborating. Already, the Court of European Human Rights rejects British legislation and the House of Commons, grumbling, amends it or withdraws it. A written constitution, a Bill of Rights, perhaps even a 'UK Federation', are on their slow way in. The British state, equally slowly, is on the way out.

And the English sense of loss? The Channel Tunnel symbolically undermines the British state, which was created out of English experience and preference so many years ago. It is not England but that old state, in its crusty uniqueness, which is the real island; something which can only remain itself by keeping a moat of water between it and the modern world.

But a tunnel is also a voice-pipe, through which echoing shouts of warning or encouragement can be heard. Up through the big hole near Sandling, all the way from France in the time of Revolution, comes the voice of Thomas Paine. He is, as he always did, asking the question which really matters. Paine asks why the English have to live in the British state? The fact that their leaders constructed it three hundred years

ago need not condemn the English nation to inhabit it for ever, still less to identify their own qualities with this particular set of rules. States are made by peoples, as shells are made by snails. When they grow confining, they are shucked off and exchanged for a better one.

England can live without Britain. The message of the Channel Tunnel, indeed, is that England will be obliged to do so, because the approach to Europe is beginning to expose the British state to the sort of radiation which will change it out of all recognition. The state has been frankly anti-European. The nation does not have to be so, and in the long ages before the constitutional settlements of the sixteenth and seventeenth centuries, England was no more or less 'European' than Denmark or Catalonia.

The mourning, then, is not for a lost physical England to be ravaged by a tunnel and a railway. It is not for Englishness, either, which will probably be enriched by its recovery of Europe and renewed by the modernisation of life and thought which will accompany it. The grief is for a fallacy: the notion that England and Britain are identical, and that with the decay of the unreformed British state a whole way of life must go into decline. But this is like saying that a man grows sick when his shirt begins to fray. All we are losing is an outdated set of institutions, an *ancien régime* overdue for replacement. And that loss is necessary, even welcome: the washing-away of waste which every community has to organise if it is to stay healthy. Perhaps, after all, the Channel Tunnel's supreme function is that of a drain.

KENNETH BAIRD

Kent: A Polarised Landscape
1989-90

What would an England that was not an island be?
French writer's query, from the *Revue des Deux Mondes*, c.1890

It is easy to recognise the individual components of the Tunnel development today, its scale and impact particularly evident at the terminal area at Cheriton, Folkestone. Many avid spectators will remember how the former intimate and accessible character of the pastoral landscape adjacent to Castle Hill and pasture land below the North Downs escarpment has been pummelled, groomed and transformed beyond recognition.

Labyrinthine, 'The Chunnel' burrows its way beneath the historic landscape of Kent – a technological wonderland, a marker of late twentieth century technology, and a sign of the new spirit of economic outreach to the Continent. Perched high above, between Summer Hill and Shakespeare Cliff in particular, defence installations abound. And elsewhere the county is dotted with traces of other such systems, fortifications and war memorials. These markers of war are themselves under threat from new developments and are in varying stages of dilapidation. A layered or polarised landscape, Kent is an accurate document of British history.

The planned high speed rail link and the many new road systems will compromise the 'Garden of England' as long as green areas remain. It is the residents of Kent who once again have to bear the brunt of this new development. Their home county of Kent is already the commuter playground for London and a primary service route between Britain and Europe.

The Eurotunnel development has seen the proliferation of surveying points associated with construction; by measuring the land we can control and create a synthetic landscape. No longer an assumption, we can all understand that the land of Kent will be threatened by further huge scale economic expansion attracted my the magnet of the Tunnel. The shrinking public access land has already been relegated to the margins of development areas and it will have to be defended from the new enemy within, the land developer, and from the demands upon it of incessant tourism. The variety of uses to which undeveloped land is now put requires the public and the developer to share in the responsibility for control and conservation of 'their' land. A strategy which nevertheless signals the end of an uncontrolled, wild nature, which we used to experience so freely. We look at the landscape anew today.

Kenneth Baird
1994

18

19
Castle Hill, showing traces of
a motte and bailey fortification,
pathways, roads and
Tunnel workings

20
Recently discovered
First World War I underground bunker
complete with explosives intact,
Newchurch area, Romney Marsh

21
Grave site headstone
commemorating a volunteer American pilot
who crashed and died near this spot
during the Battle of Britain,
Newchurch area, Romney Marsh

22
Cheriton Terminal area
under construction

23
Dungeness,
looking toward Denge Beach
and restricted military training
danger area

24
First World War chalk memorial
on the North Downs Escarpment,
north east of Lenham,
near Charing

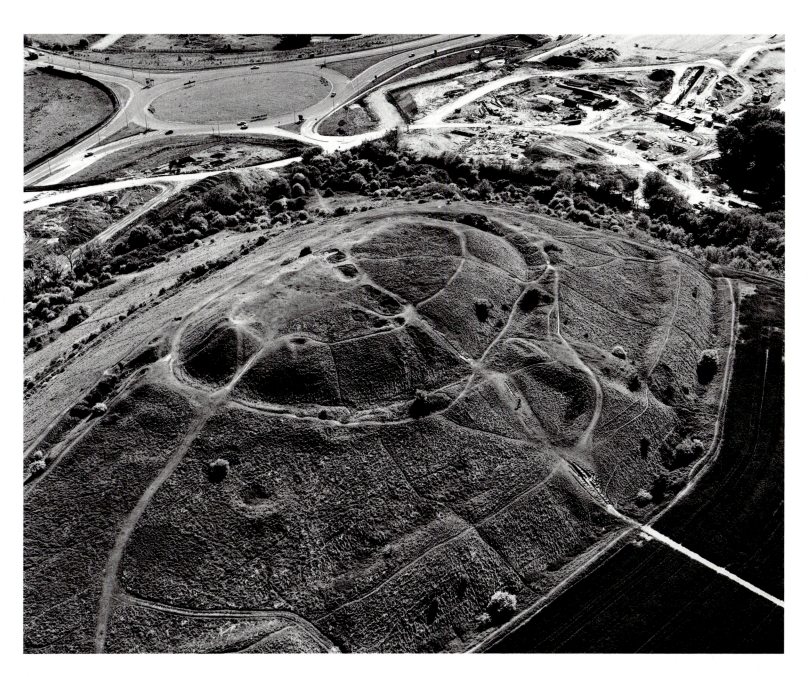

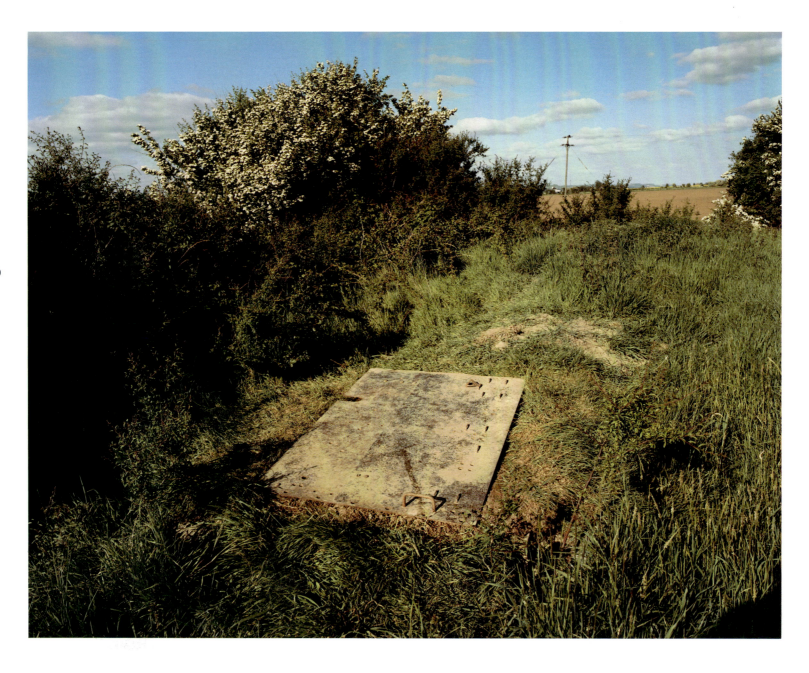

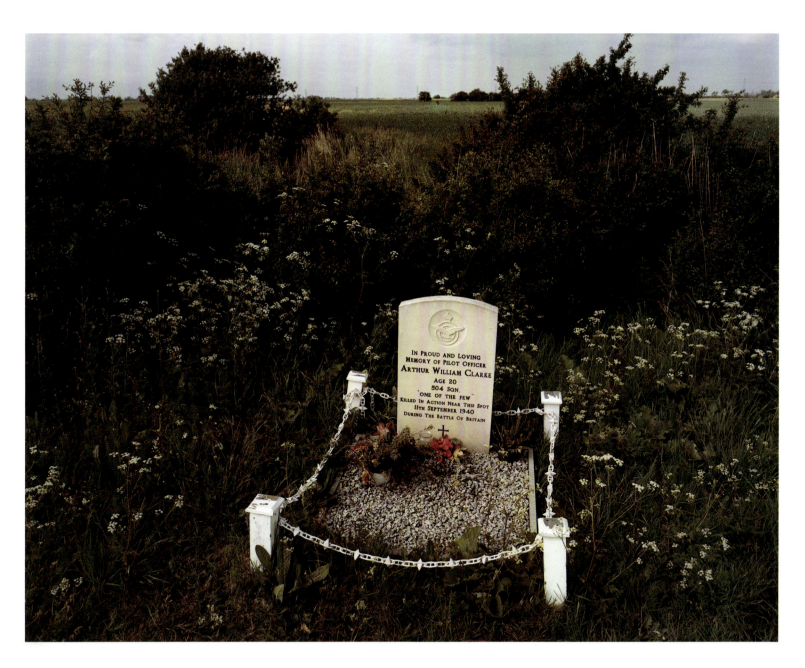

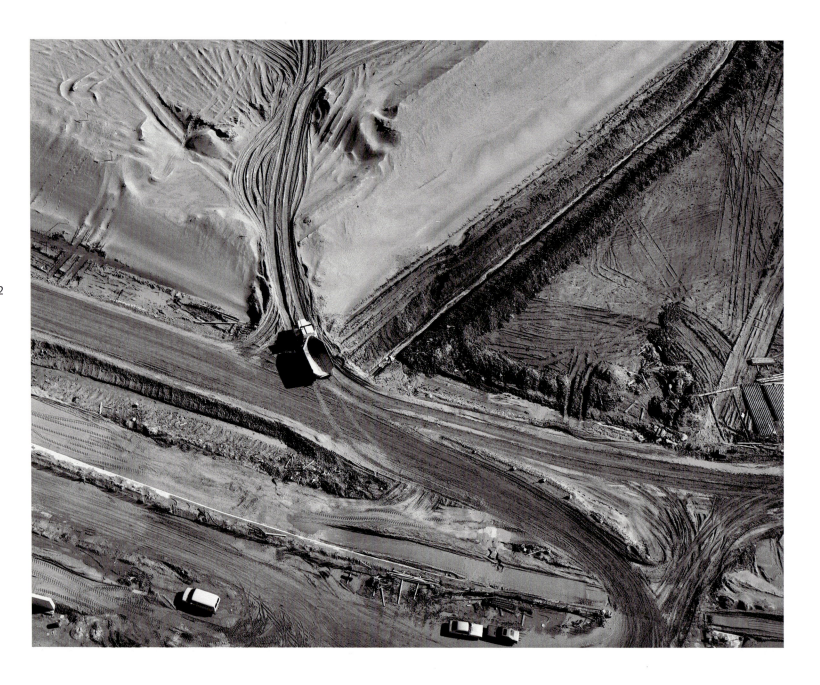

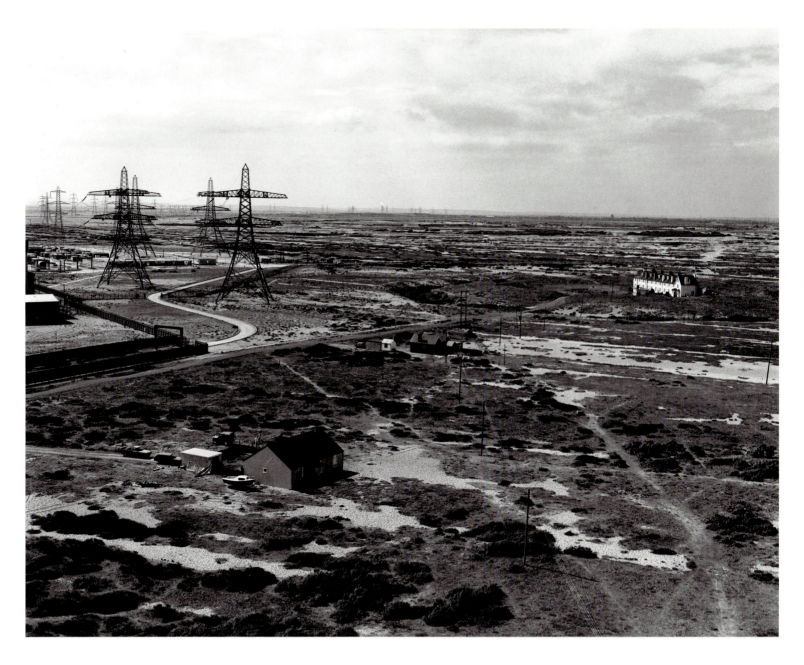

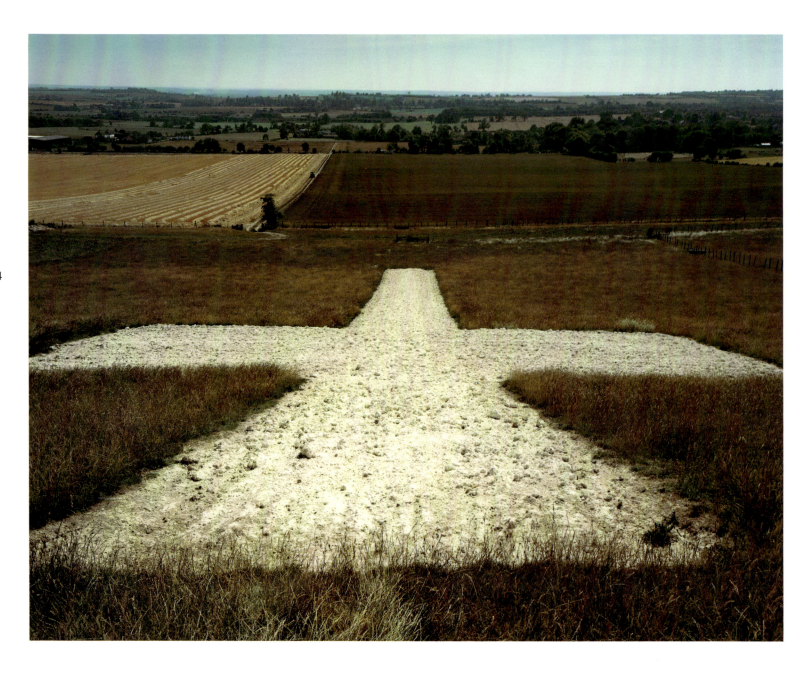

PETER KENNARD

Welcome to Britain
1991-92

Welcome to Britain presents an anatomy of the society that confronts
visitors to Britain on arrival in Waterloo station via the Channel
Tunnel.

These photo-works are part of a larger project which makes use of
pallets and plywood onto which photographs are then pasted to
create a metaphor of human and industrial redundancy. Here, kitsch
tourist souvenirs are set against photographs of a Britain in ruins. Both
types of images are contaminated with grime.

On one level, *Welcome to Britain* displays the darkness, rather
than the light, at the end of the Tunnel. On another level, it registers
a growing scepticism about the power of photography ('drawing with
light') to illuminate the darkness.

David Evans

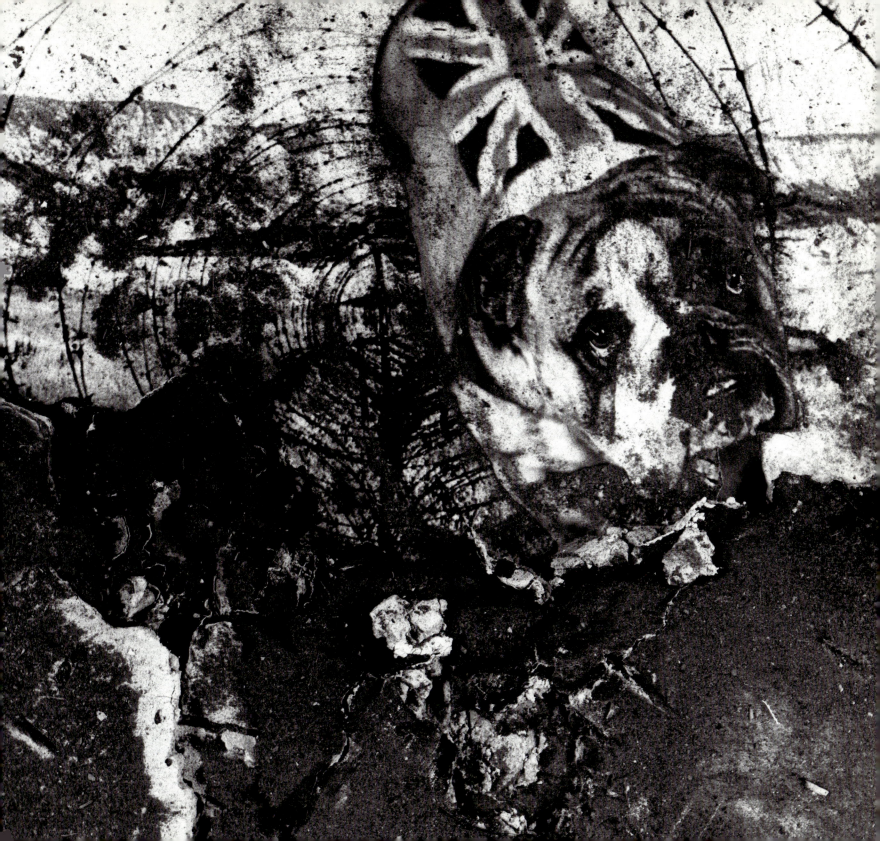

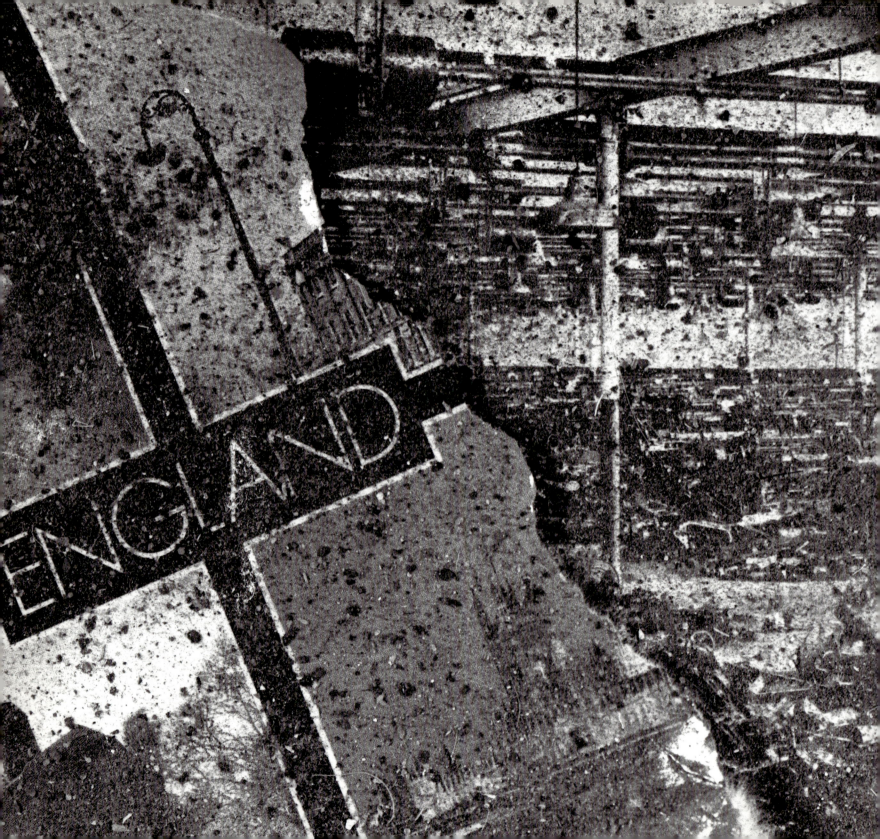

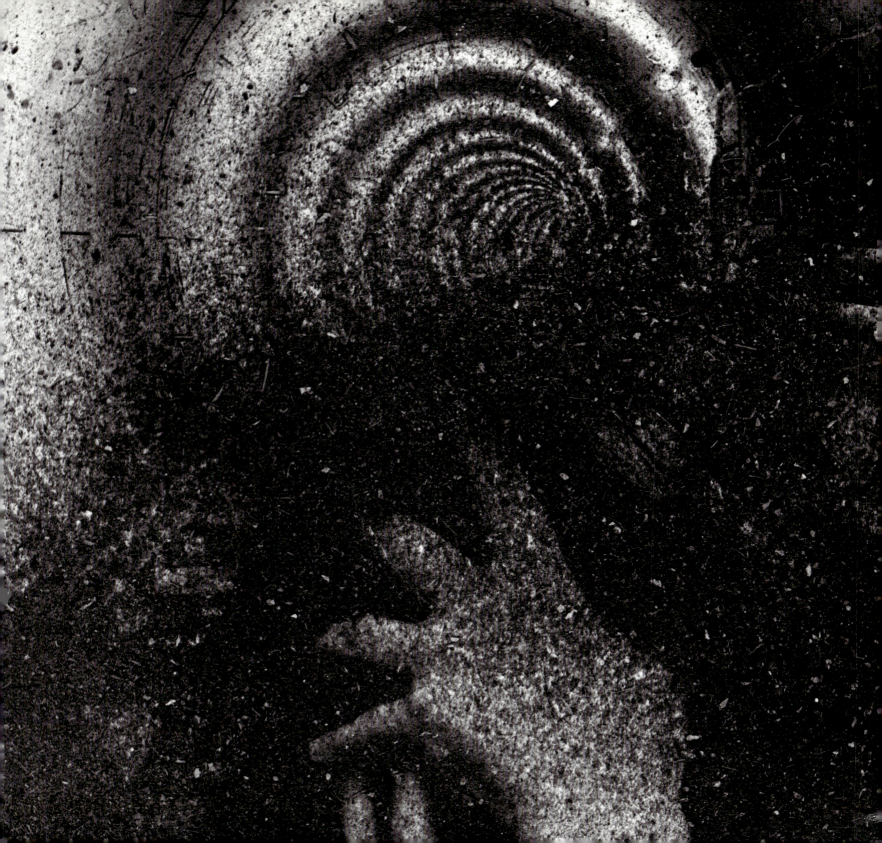

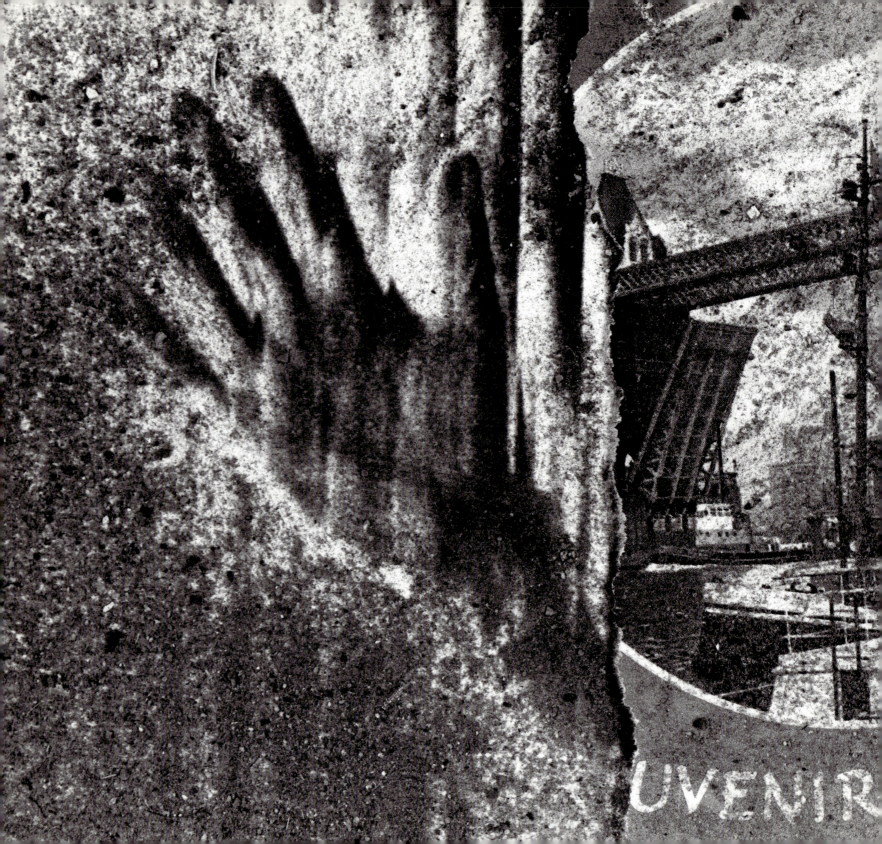

UVENIR

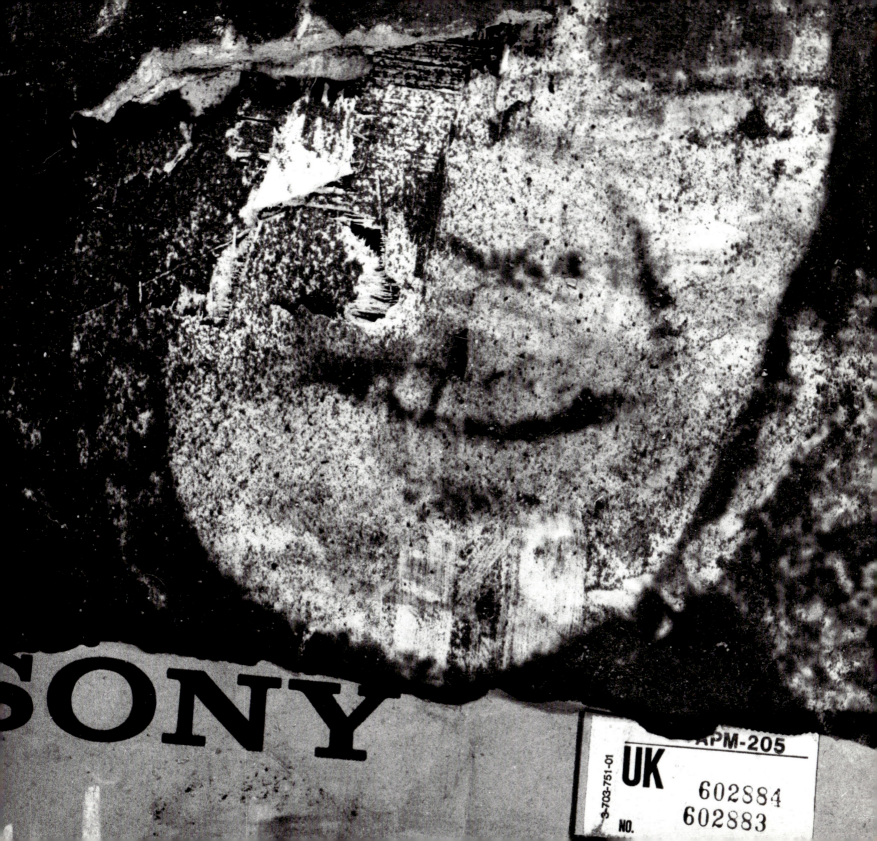

Medical record
Metabolic unit
"B" Block wards
Medical supt.
dept.
Fran
labs
Centr
Catering dep
Treasurer's d

CLOSED

BIG BEN

JULIAN GERMAIN

Ashford and Folkestone
1989-90

Since the War, Kent has suffered more than most counties from
'London suburbanisation' and its consequent effects, such as
congestion and expensive house prices. In the late 1980s the area
entered a new phase of dramatic and rapid change with the advent of
the Channel Tunnel and its rail and motorway links. Ashford and
Folkestone may be fundamentally changed by the year 2000. Indeed,
it is likely that no port will exist in Folkestone, its traditional link with
the sea removed. The centre of Ashford may have become a huge
passenger terminal, and its outskirts have already been handed over
to the developers.

The irony is that the Tunnel is merely a continuation of Kent's
historical role as the 'gateway to Europe.' Ever since the Pilgrims,
travellers have passed this way on their journeys to and from the
Continent.

34 Julian Germain
 1990

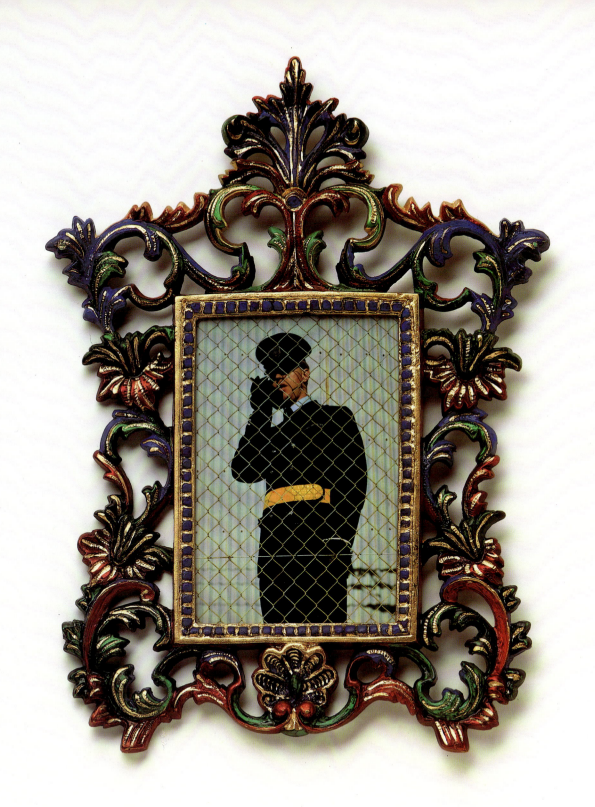

36

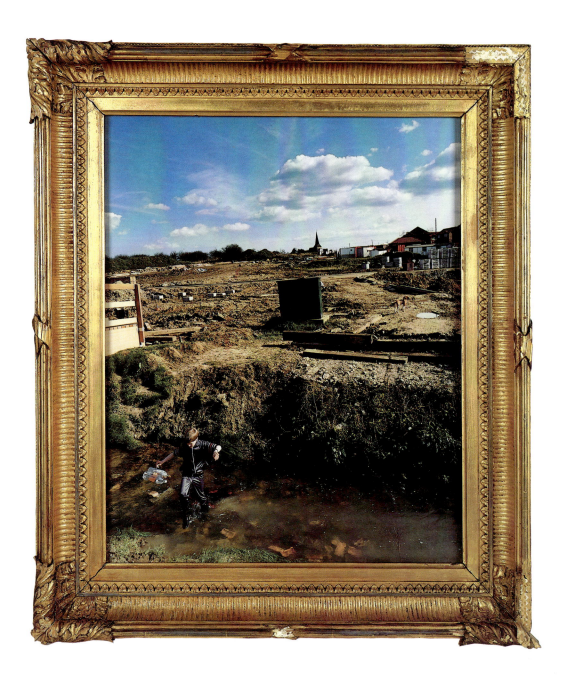

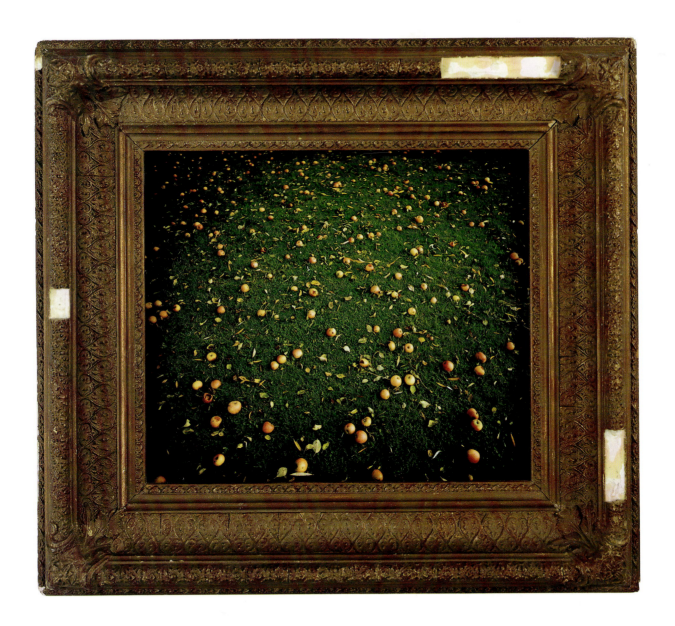

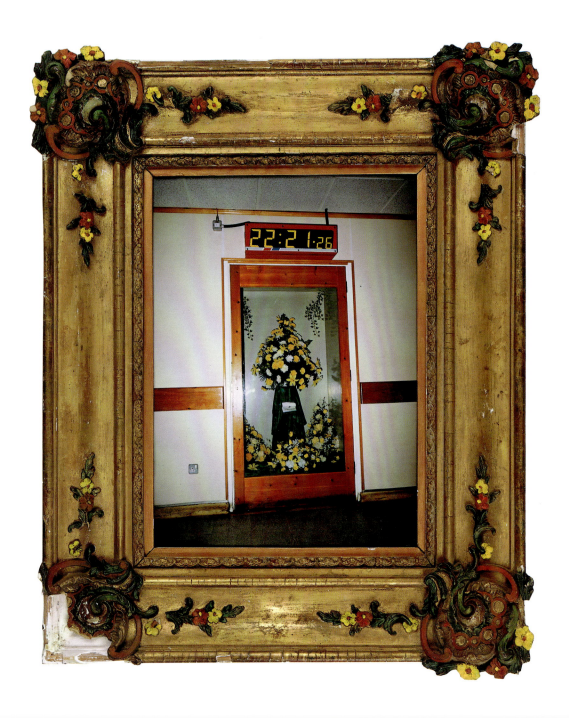

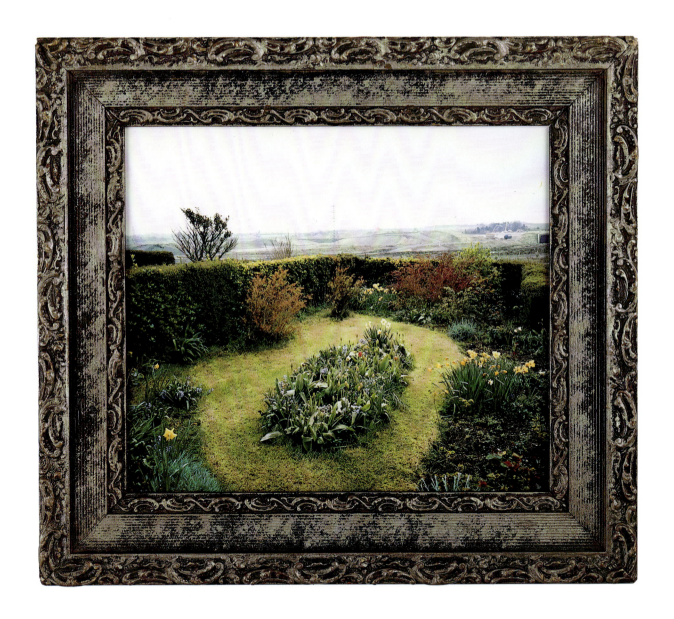

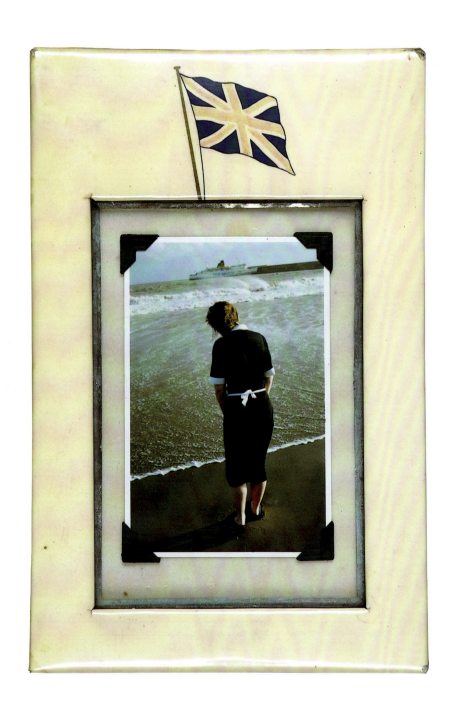

PATRICK SUTHERLAND

41

The Garden of England
Pictures from the Contemporary Countryside
1991-93

'We like living in the country, we wouldn't want to go into the town, but if you don't have a motor you're stranded. There's no facilities at all, we haven't even got a village shop now and there's only three buses a day. All the youngsters have gone from this way now and there's none coming into the village.

Years ago you knew everybody. Now with houses being sold and resold you don't even know your neighbours down the road. It's all private land now, a lot of the farms round here have been sold and split up into lots and they get their mobile homes on them and they have a little field with a couple of ponies. Everywhere you go these days you see ponies in the fields.

Years ago everybody stayed put. They're all Townies who come out here now – people from London. You can always tell the Townies – they've got their plot and they've got all these floodlights shining out. They come down from London where it's all lit up and all of a sudden they can't see nothing. It's like Blackpool illuminations in this village – you don't need your headlights on to drive at night.'

o

'I feel the presence of the Lord much more clearly out here.
I mean God's everywhere isn't He, but it's just that in the city there's so many distractions. It's like interference on the wireless, here in the country you can tune in better. That's what I feel anyway.'

o

'I was the fifth generation of farmers in the family. It's been an enormous wrench to give up the way of life. No one says directly that the land is your responsibility but it's just assumed. Previous generations of farmers have handed it on to you for nothing and the expectation is that you are steward for your lifetime and you pass it on. It comes very hard to realise that in your generation it's not going to work any longer.'

From interviews with Kent residents

42

43
Portaloo, Chilham Castle

44
Abandoned diner, Chilham Castle

45
Mobile home, Challock

46
Clay pigeon shooting, Chilham

47
Golf driving range, Ashford

48
Abandoned garden centre
Lenham

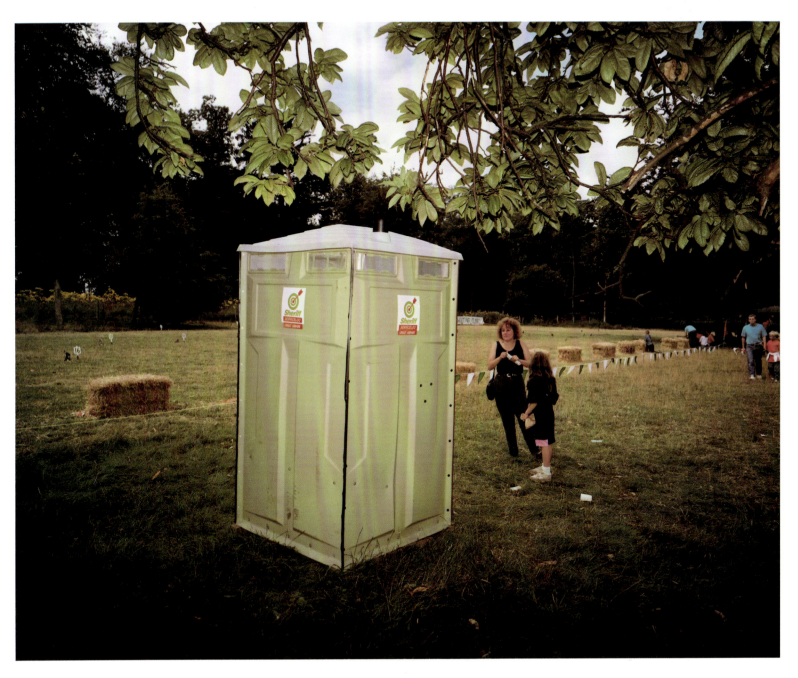

44

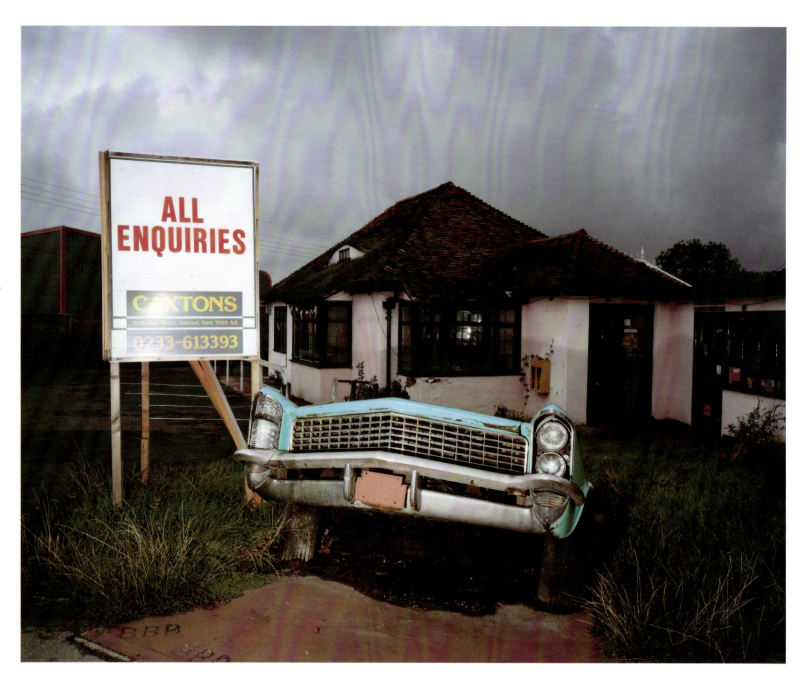

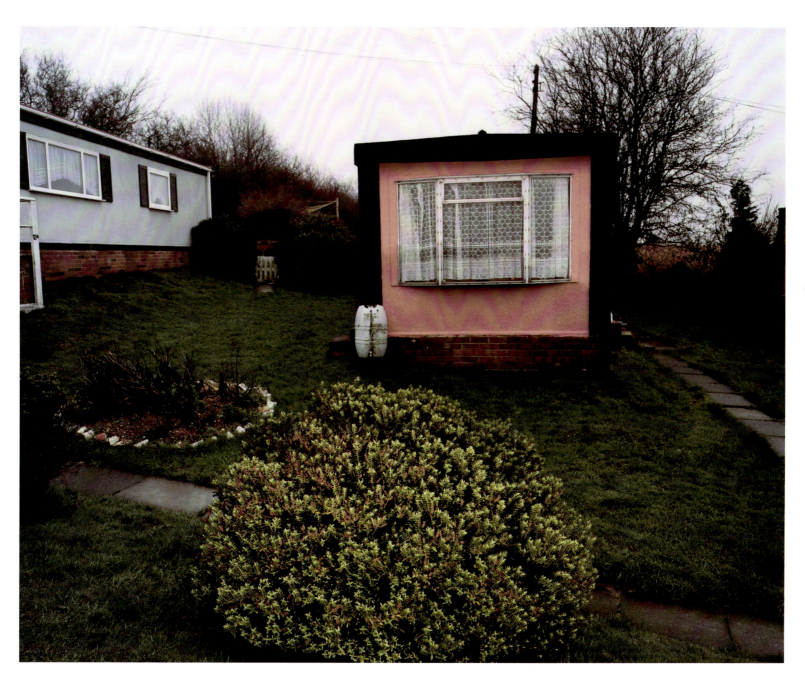

46

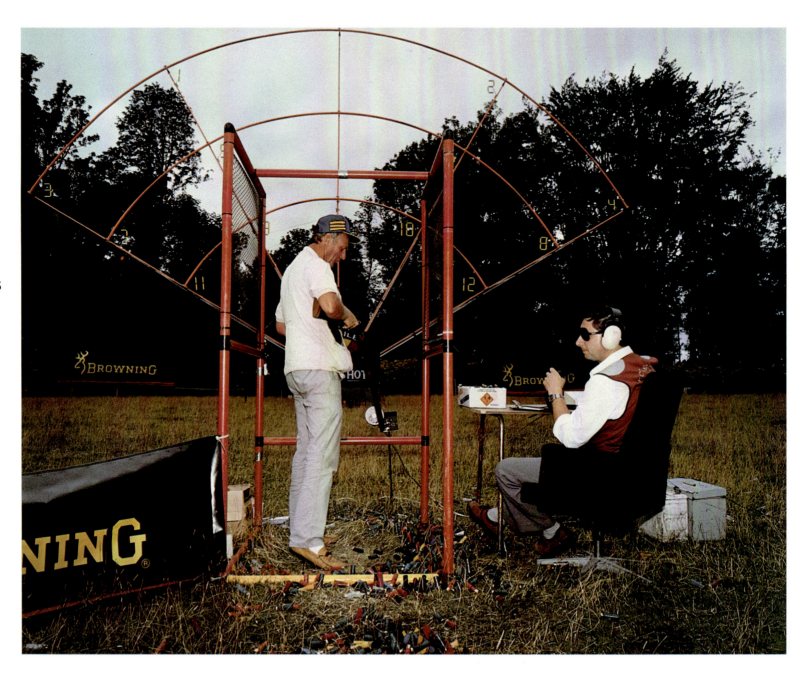

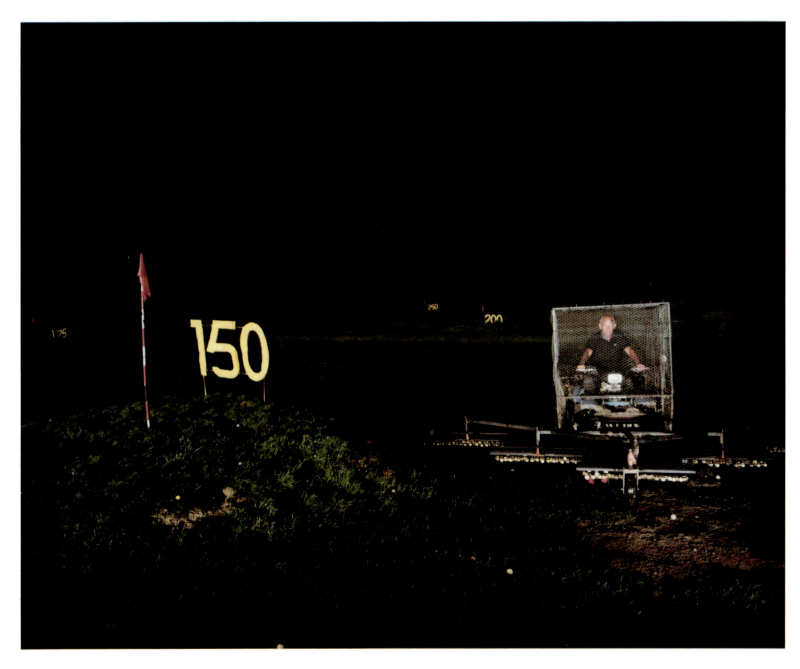

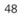

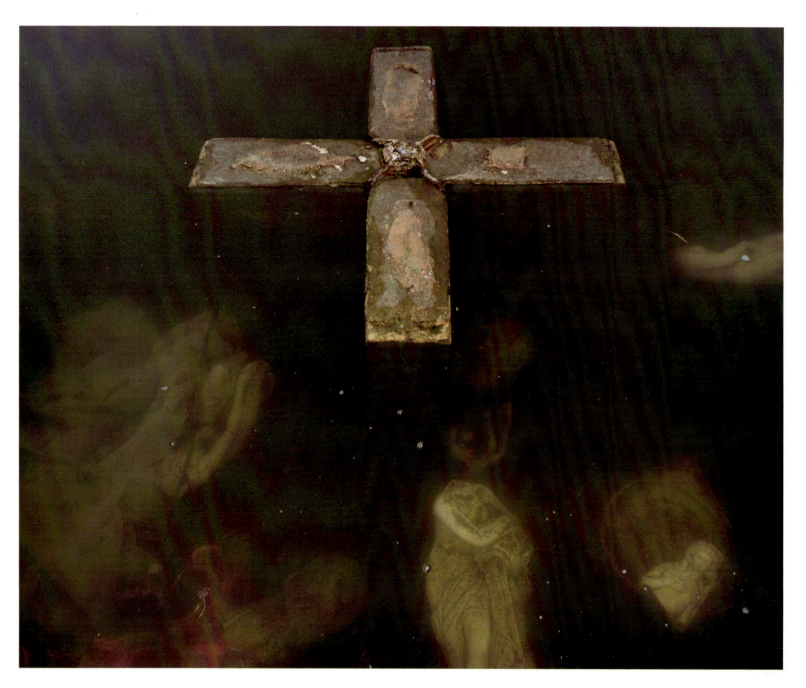

SIMONE CANETTY-CLARKE

The Orchards of Kent

1990-91

Now pause with yourself, and view the end of all your labours
in an Orchard: unspeakable pleasure and infinite commodity.

William Lawson, *A New Orchard and Garden,* 1618

Simone Canetty-Clarke's first picture presents a bounteous and splendid
countryside, the English pastoral idyll: a churchyard and tower, cloaked
in hanging boughs of ancient hardwoods punctuates the outermost
edge of the orchard where blossom leaves still tremble. Soon the apples
will grow round and blushing and hang heavy, testing the hold of the
delicate silver-grey branches that nurse them into being.

 Elsewhere, but still charting the orchard edge, Canetty-Clarke records
altogether contrasting vistas, where the charred remains of pineapples
are heaped incongruously, and heavy steel gates and high fencing
disrupt the view. And now regimented like soldiers even the trees take
on quite another character to that which they first assumed.

 This is the new face of the 'Garden of England'; fruit as intensive
agri-business where maximum yield is all important. Since the early
1970s Kentish orchards, like those in the rest of Britain, have been in
decline and the introduction of modern practices mean that dwarf trees
have replaced the older and more varied standards and pesticide and
herbicide use is the norm. Despite mechanisation, the orchards still
provide a job for some, although they, like the varieties once picked, are
far fewer in number.

 Once cultivated land now stands neglected. Here, tangled corners of
mixed woodland and scrub thrive creating a strange and wild beauty
which soon envelops any structure or trace of human origin. In the
adjacent factory heavy odours of ripe and battered fruit linger and
infuse the surroundings. The harsh reality of the production line,
however, is that any romantic traces of the past are quickly dispelled.

Jane Alison

Works untitled

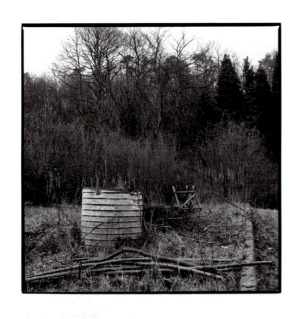 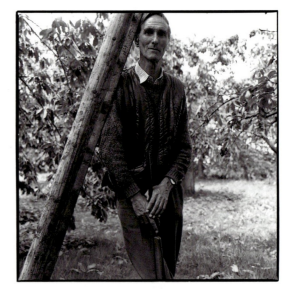

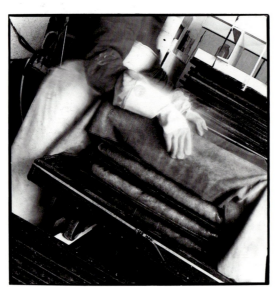

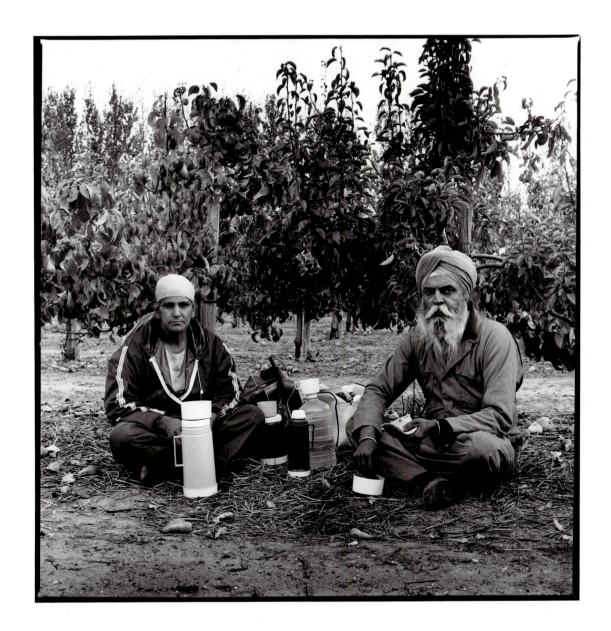

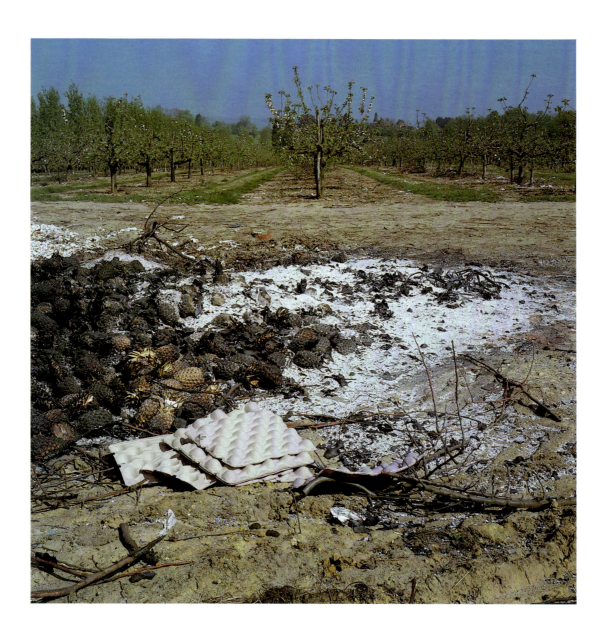

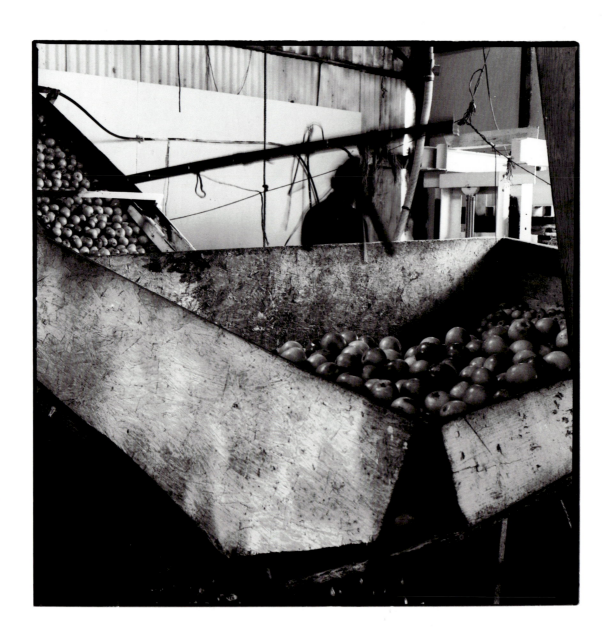

JANINE WIEDEL

Dover: A Port in a Storm
1989-90

Dover is the world's busiest seaport town with millions of passengers and tons of cargo passing through each year. Yet few travellers spend time in the town itself. To the outsider it is not an easily accessible town; with no theatre or cinema and few restaurants, there is little to attract and hold the casual visitor.

Many inhabitants are from families whose links with this unique seaport stretch back through many generations. There are constant reminders of the town's long history, from the Roman invasions to its recognition as one of the Cinque Ports. Dominated by its ancient castle, Dover figures prominently in the Doomsday Book. Proximity to France afforded it a major role in many of Europe's wars and has helped to forge the particular character of the town and its people.

Dover remains staunchly English and individualistic, shaping attitudes that seem impervious to the constant flow of traffic to and from the Continent. Bingo, tea-dances, boot sales and members only clubs, reflecting the close-knit communities within the town, provide the key meeting places. The people evince a troubled concern for the future and a nostalgia for the past.

Janine Wiedel
1991

58

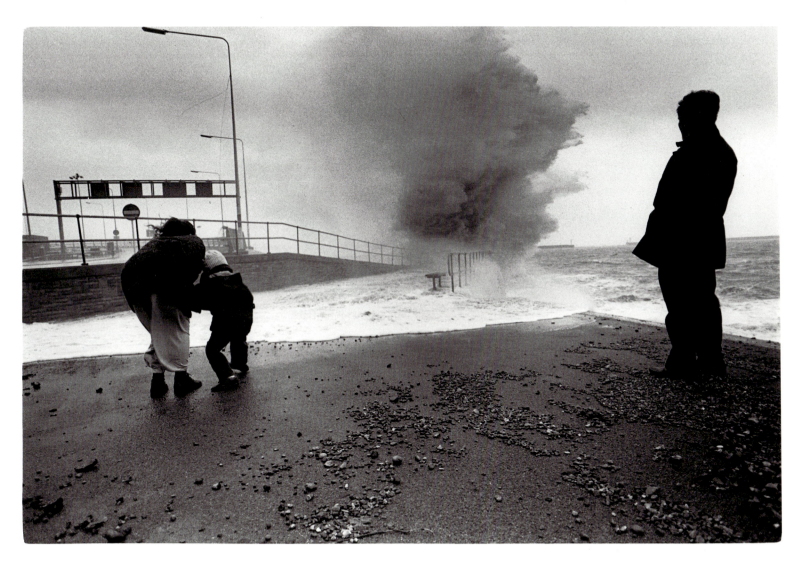

60

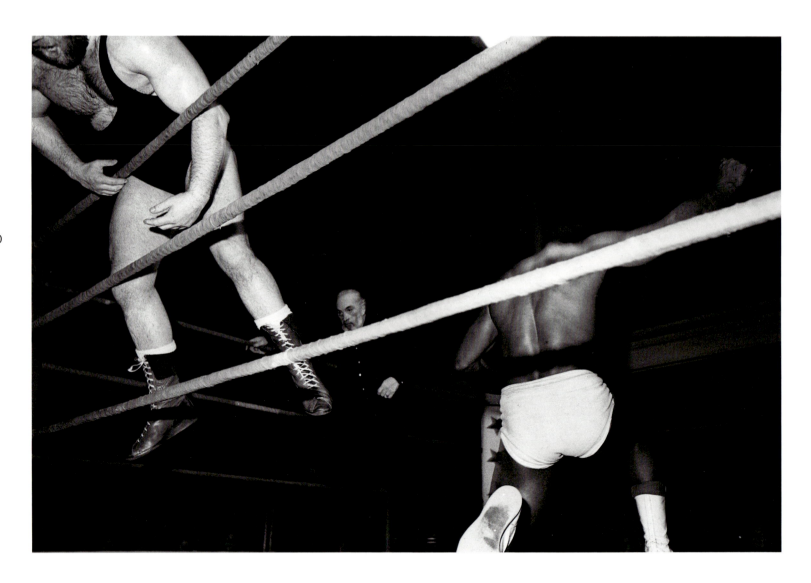

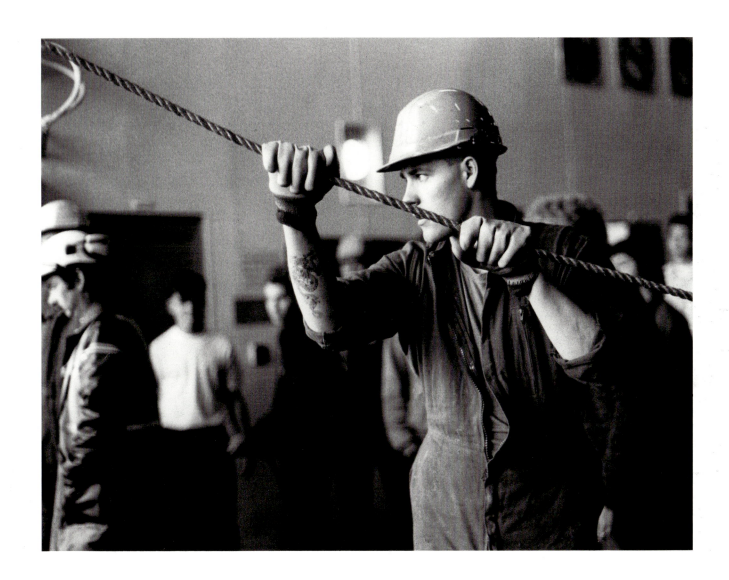

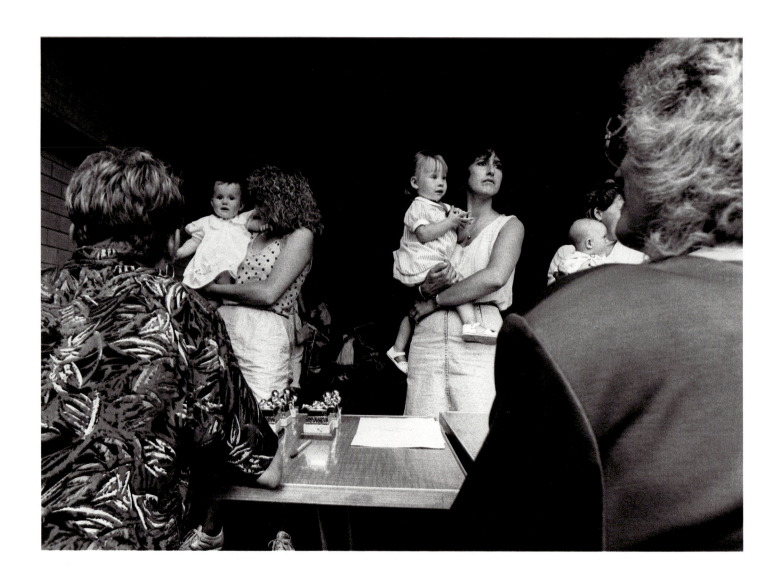

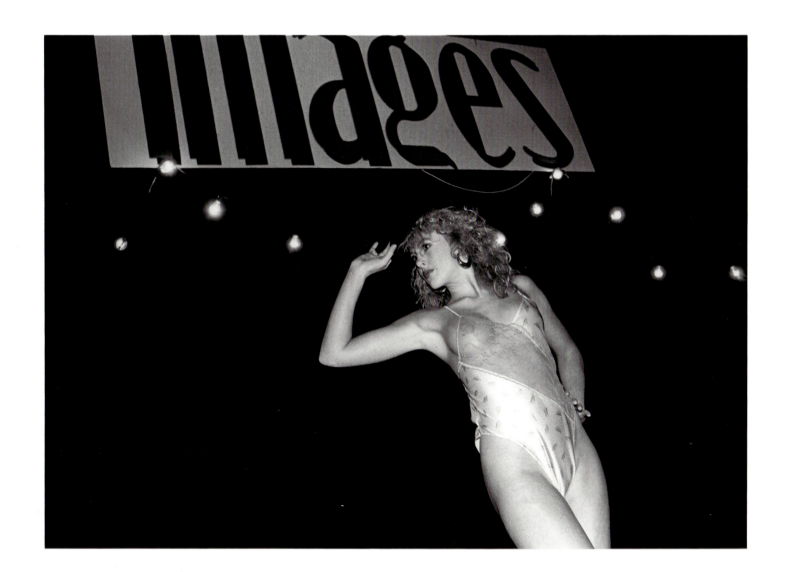

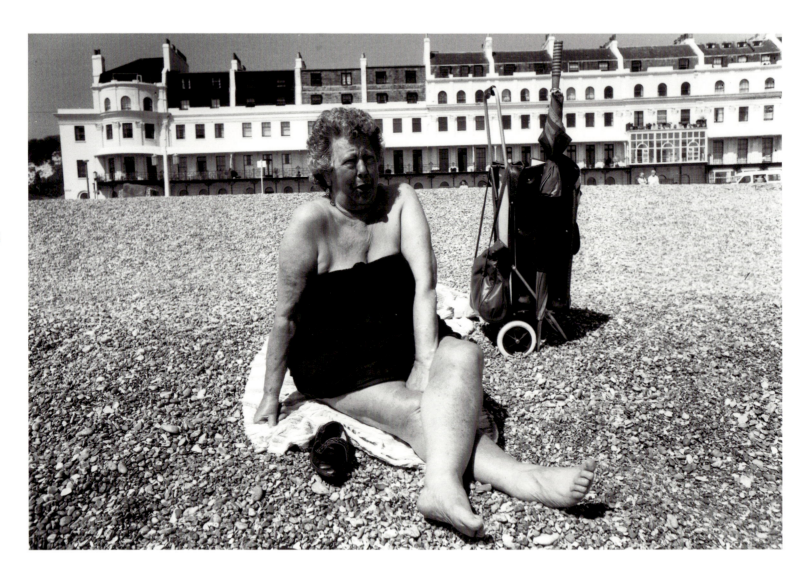

MALCOLM GLOVER

Coastal Exertions
1989

Malcolm Glover has studied the characters and characteristics of East Sussex, responding to the diverse nature of people living and working in the region. He set out to capture the sense of change brought about by an increasingly transient population and observes his subjects with a quiet sense of humour and compassion. The empathy he shows is special to his work and sets it apart from the more ironic and critical colour photography of the Eighties.

Brigitte Lardinois

67
Music workshop,
Zap Club,
Brighton

68
Lewes cattle market

69
St Leonard's ladies bowling match

70
Hove seafront, summer

71
Tic-Tac man and woman,
Brighton Racecourse

72
Newhaven to London
commuter train,
6.55 am

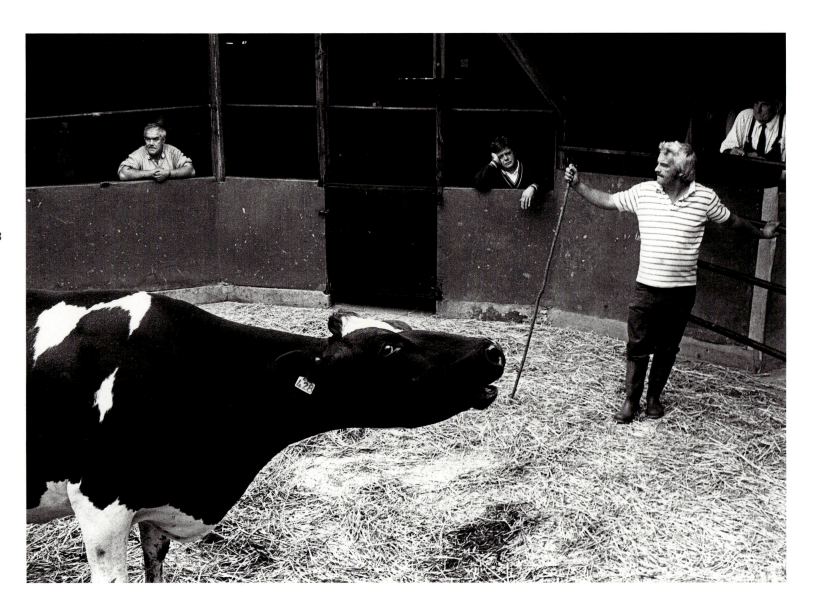

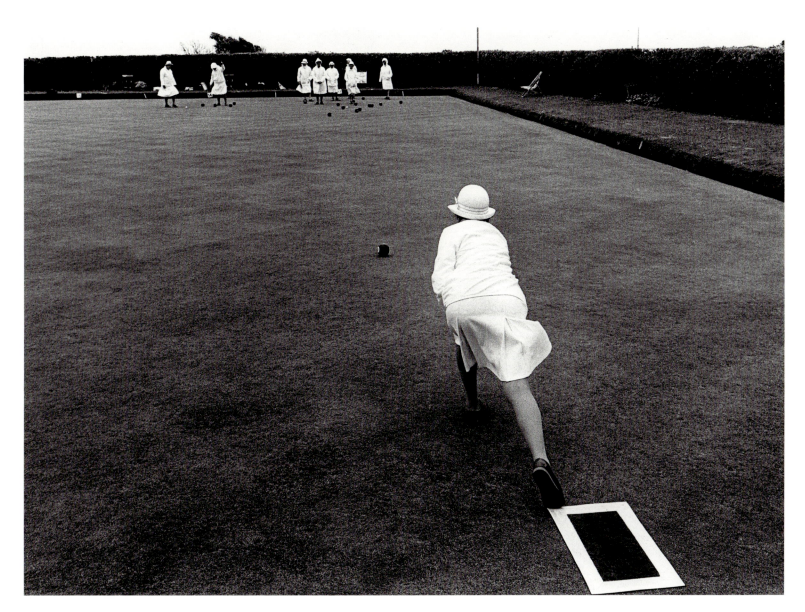

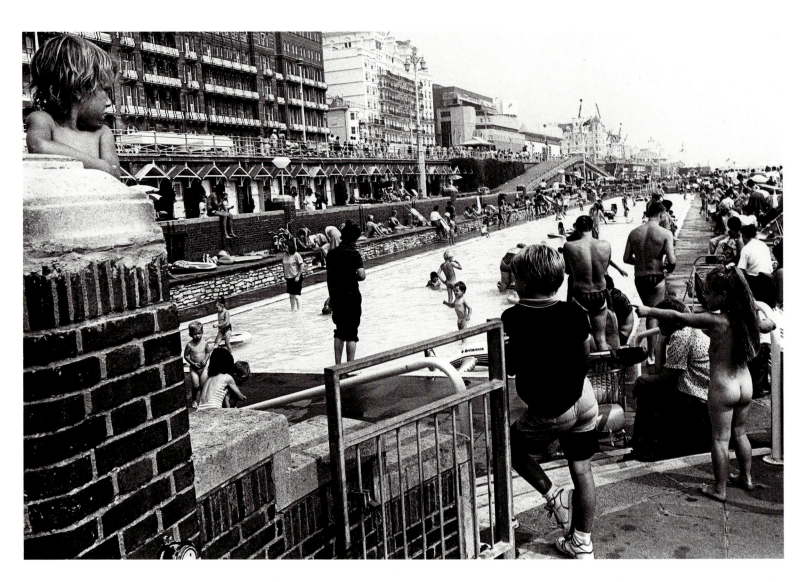

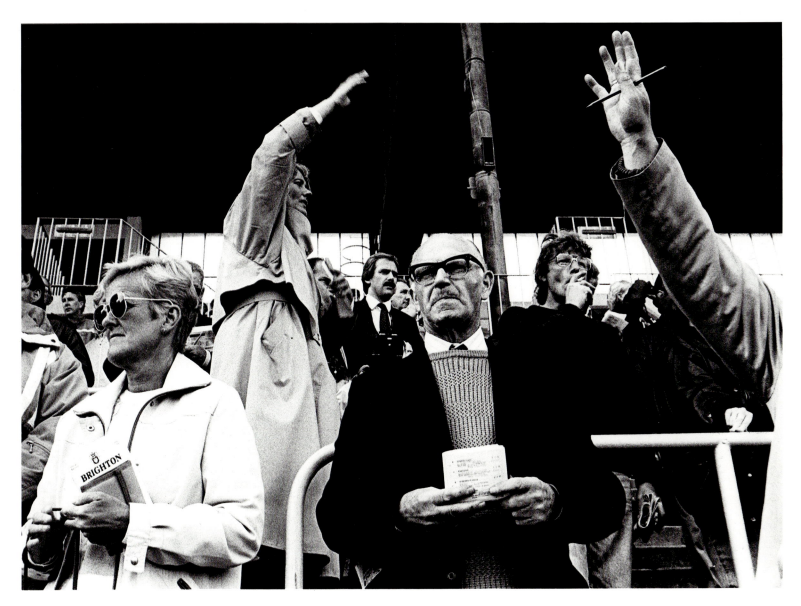

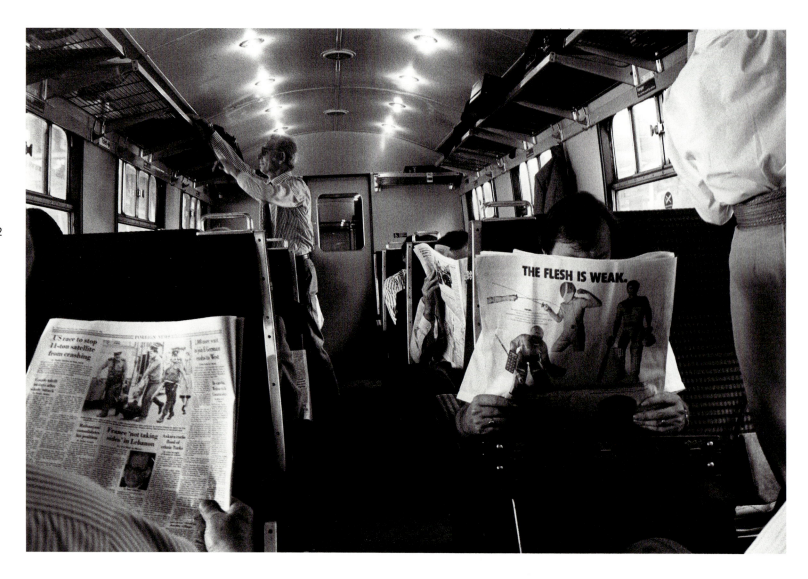

ANNA FOX

The Village
Women, Compton, West Sussex
1991-93

In collaboration with Val Williams

The modern village is a stage-set for our aspirations and our dreams of an idyllic past. It has a super-real and sometimes surreal authenticity. Cottages, which housed the desperately poor families of the agricultural working-classes now feature in the pages of *The World of Interiors*. Lovingly restored, they have become homes for two rather than ten. They have French kitchens and Scandinavian bathrooms and are cleaned by ladies from the council estate whose grandparents once lived in them.

Anna Fox's photographs of Compton in the 1990s defy the meticulously crafted myth of country life. She has looked without nostalgia at the modern village, gone beyond the facade and portrayed it as an entirely modern phenomenon. Her portrait of Compton is more fearful than satirical. Like Gretel creeping towards the wicked witch, she is both fascinated and alarmed by what she sees. But she edges her fear with irony, appreciating that wit can be more incisive than anger.

Compton's women emerge from the photographs as decorated high priestesses – an awesome chorus of ancients who administer the rites, write the laws and, in genteel whispers, cast judgements on those who have erred.

When the socialising is over, the coffee cups washed and the bunting put away, Compton people live privately, in neat houses surrounded by lawns and hedges. Like an inquisitive being just landed from some distant planet, Anna Fox has explored a mysterious world of an alien people, peeped over their hedges, crouched behind their shrubberies, wondered at their rituals and their conceits.

Val Williams

Works untitled

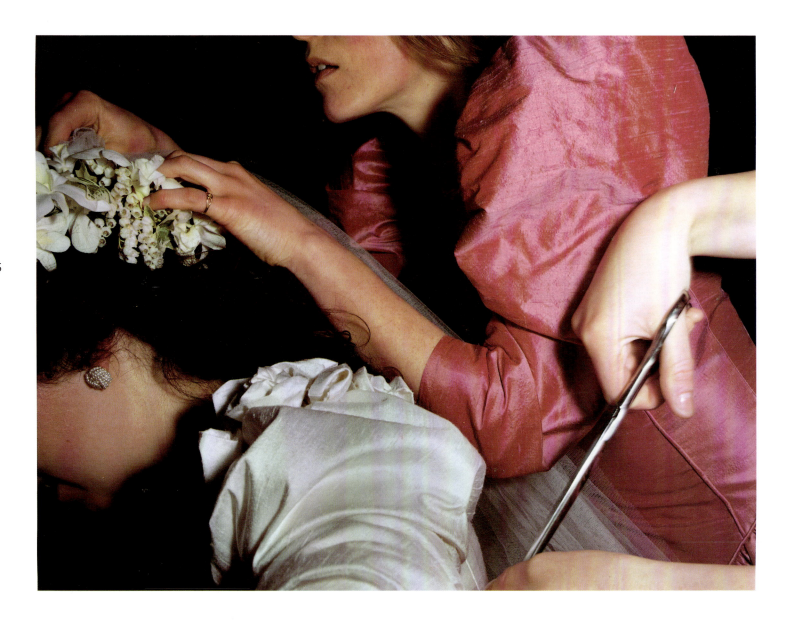

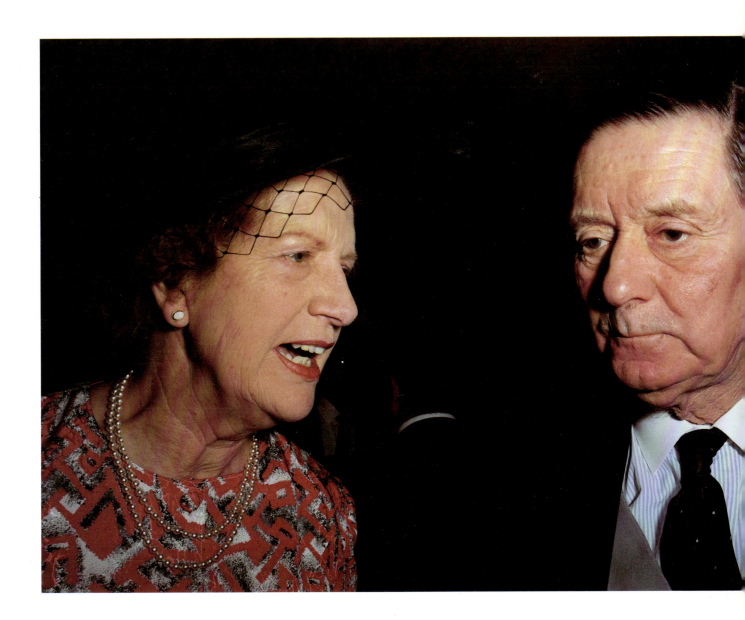

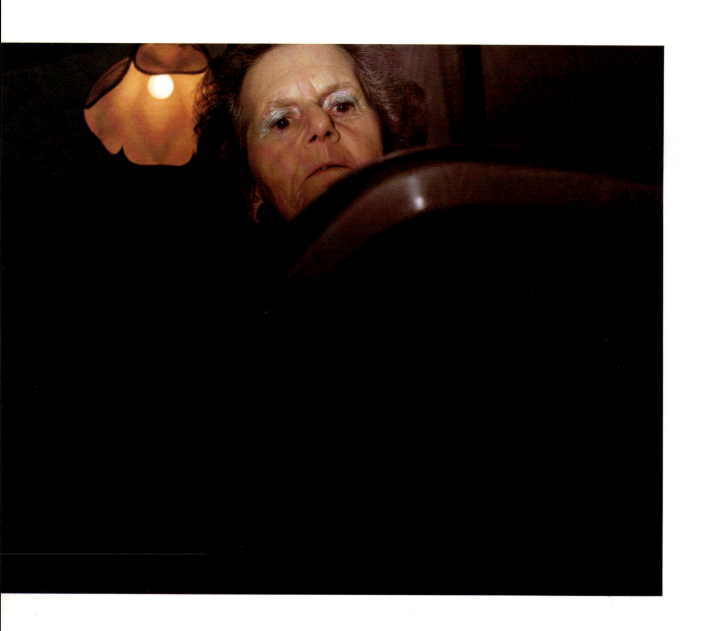

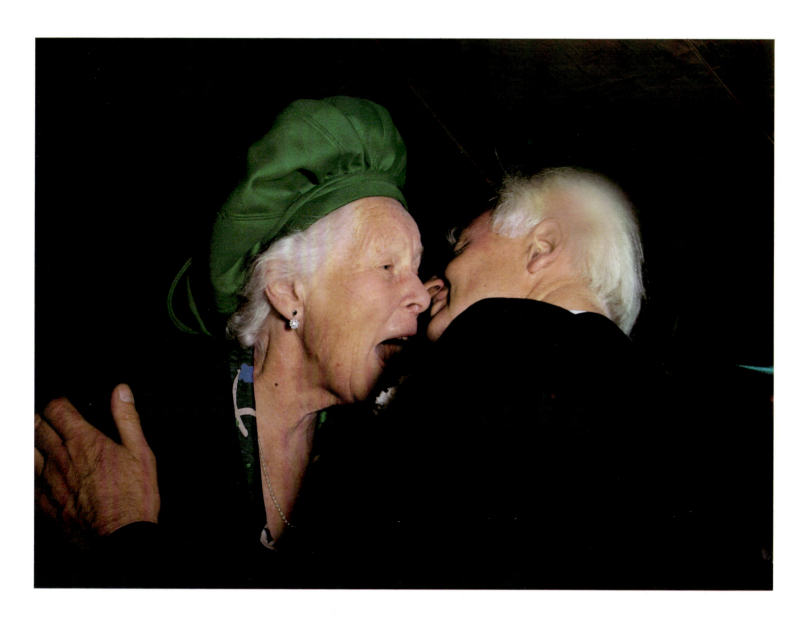

PAUL TREVOR

Face to Face
Money Market and Street Market
1992-93

We gaze out distractedly across boundaries both physical and cultural. At times our thoughts are turned inward and the face we present to the world is a mere tissue of being, a studded mask. It is this visage that Paul Trevor has made the focus of pictures taken variously in the City and East End of London.

His photographs capture a moment of contact which is of necessity and convention fleeting. It is the crossing of paths and sometimes meeting of eyes which we all make, but also often avoid in the course of a day as we walk the streets. In these short moments of recognition, repugnance or empathy we touch something within and outside ourselves. Occasionally our gaze follows the object of our interest, but more often it flits across space, jumping from one subject to the next, to settle on bits of things and buildings and body parts that we have no use or time for. And so we move on.

Here, we are forced to linger a little longer. The camera is close and we re-experience the tension that exists between strangers thrown together. And now we needn't avert our eyes for fear of embarrassment or self-disclosure or unwelcome attention. Trevor's pictures reinforce our awareness that we are ultimately alone in the world, in a strange cocoon of a body through which we both reveal and hide ourselves.

Jane Alison

82

Works untitled

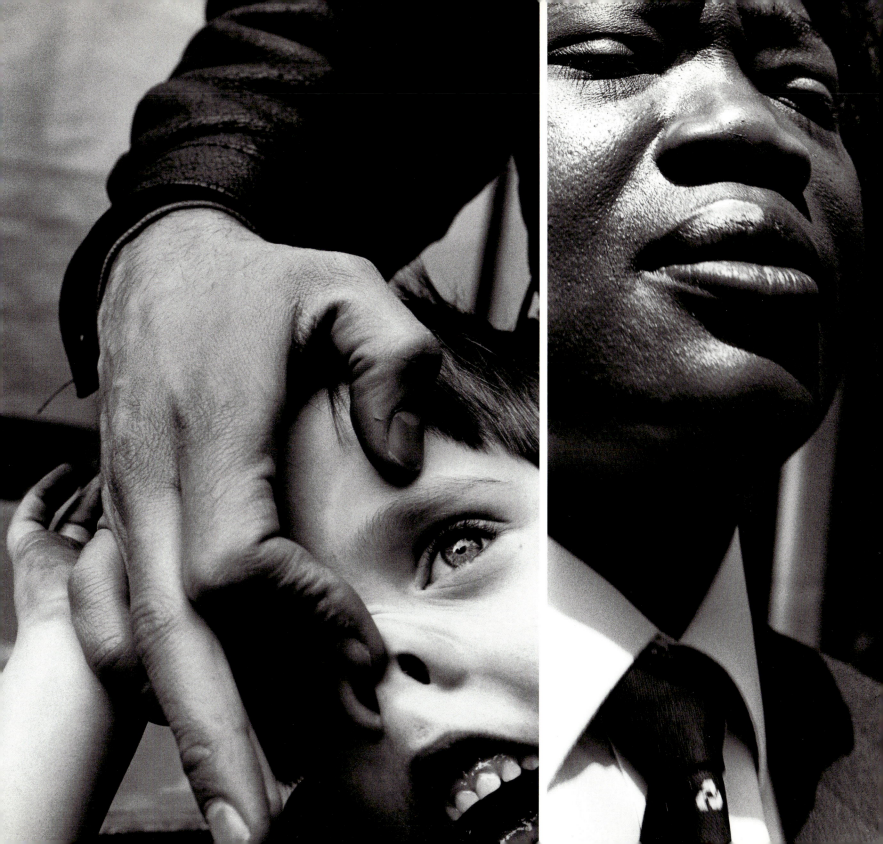

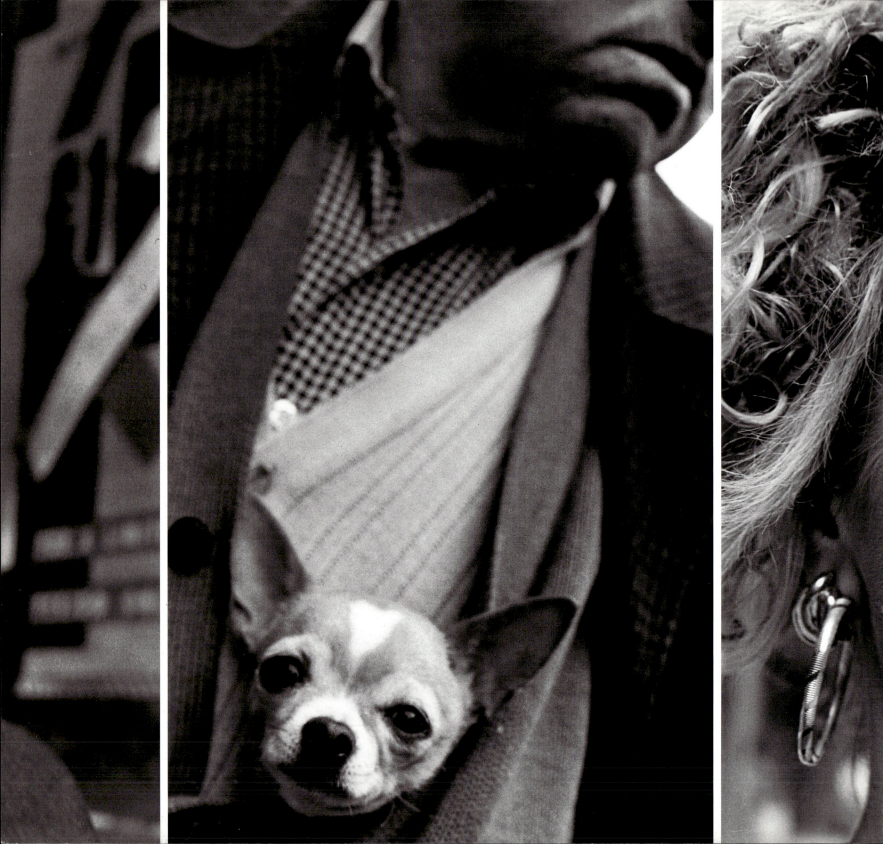

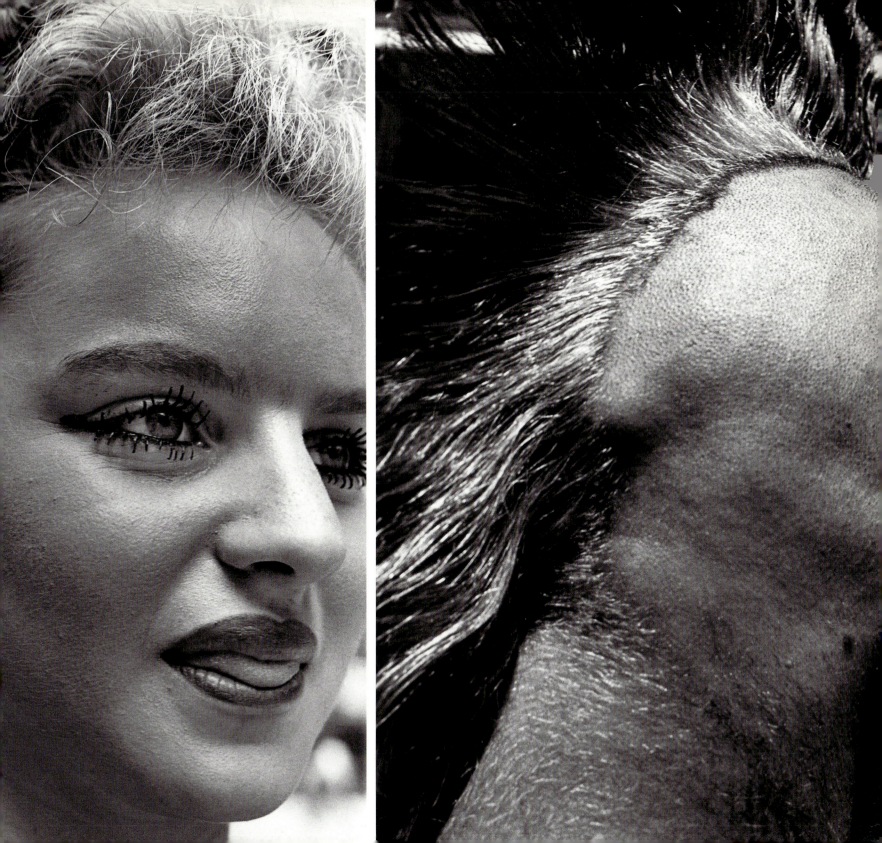

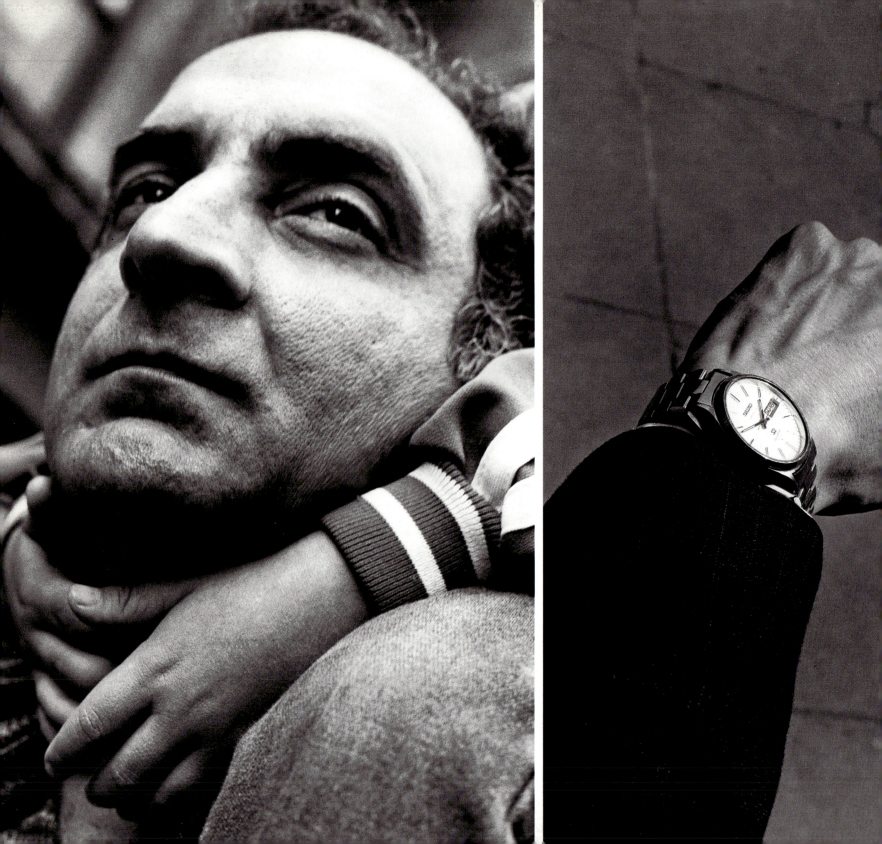

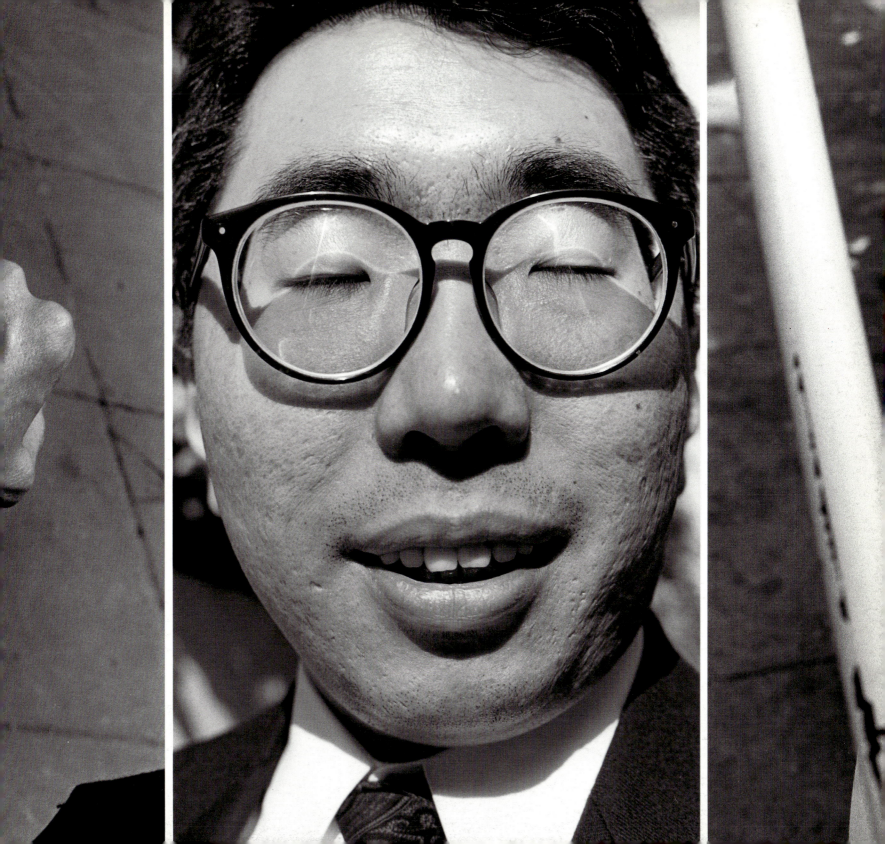

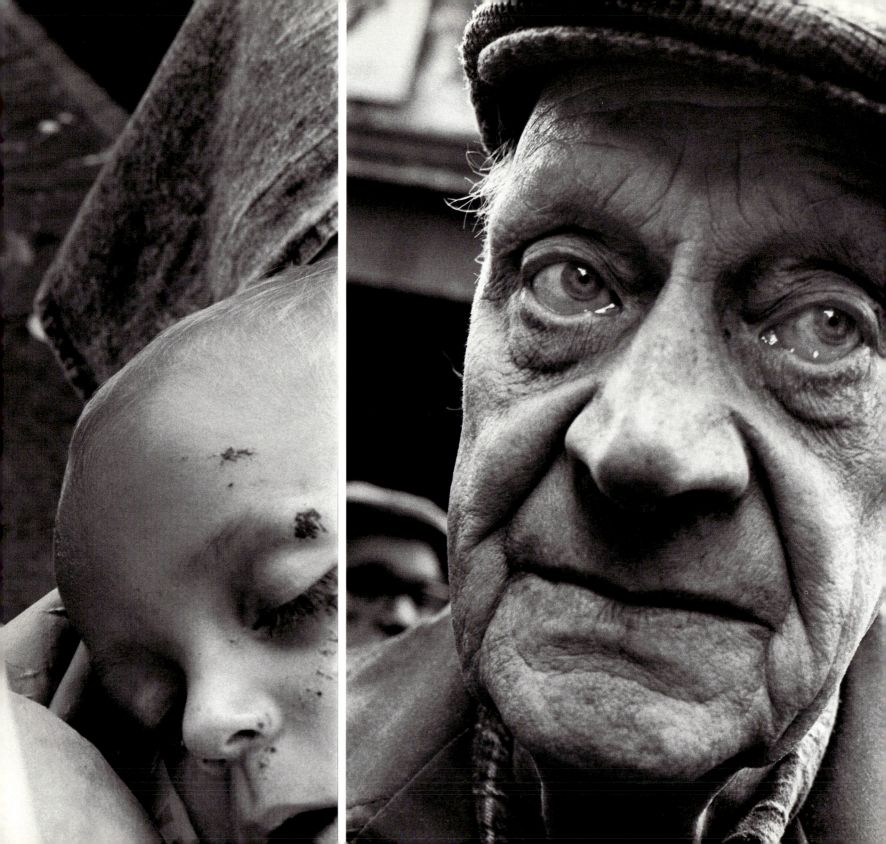

HUW DAVIES

Home from Home
The British in the Pas de Calais
1992-93

Like the Eighties our evening ended badly.

It seems hard to remember it all now – with unemployment at the three million mark and house repossessions at an all time high – but that's how it was. Back then.

Property prices in particular were going through the roof. Then, over half-a-million Londoners left the city for the country, forcing up the price of cottages and making them unaffordable for locals. Farm-yards became barn-conversions. Fields became 'The Paddocks.' Commuters replaced countrymen; Porsches took the place of pigs; leisure of land-work. Already the English countryside was owned by the well-off, but now it became colonised by the mass of the middle class.

And as rural England became occupied, France was the new frontier. In estate agents' lingo it was the 'New England' and Nord Pas-de-Calais was re-christened South Kent.

From *Toujours Calais* by Nigel Duckers
commissioned by the CCPM

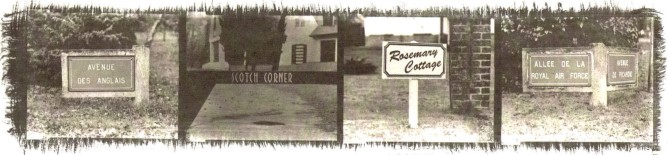

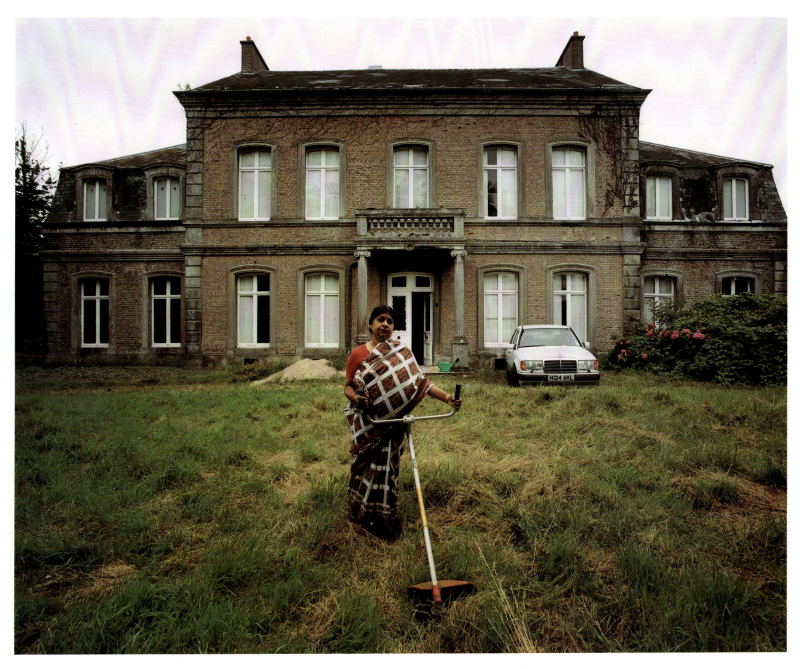

Restaurateur, Shreeran Vidyarthi
Vron

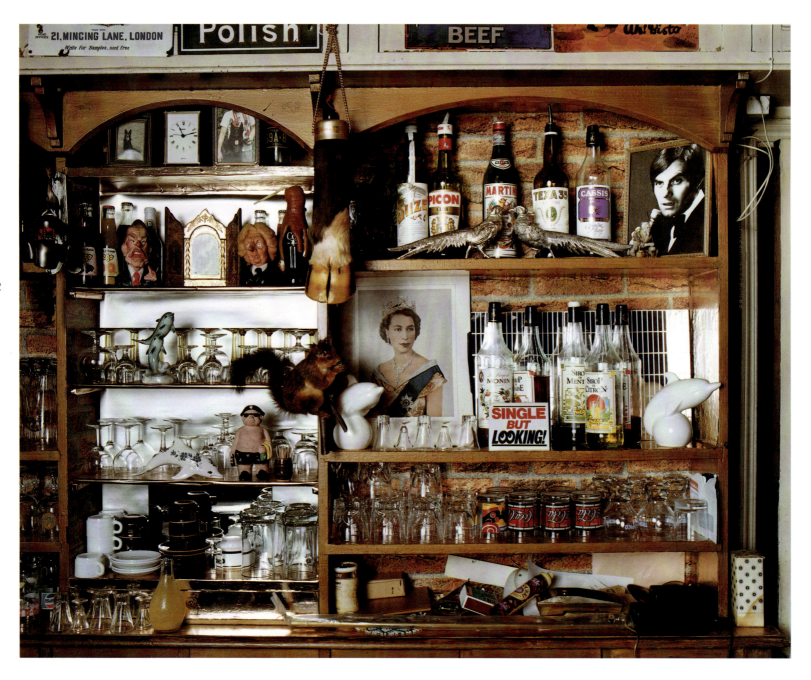

Detail
Bar Dolphin
Enquin-sur-Baillons

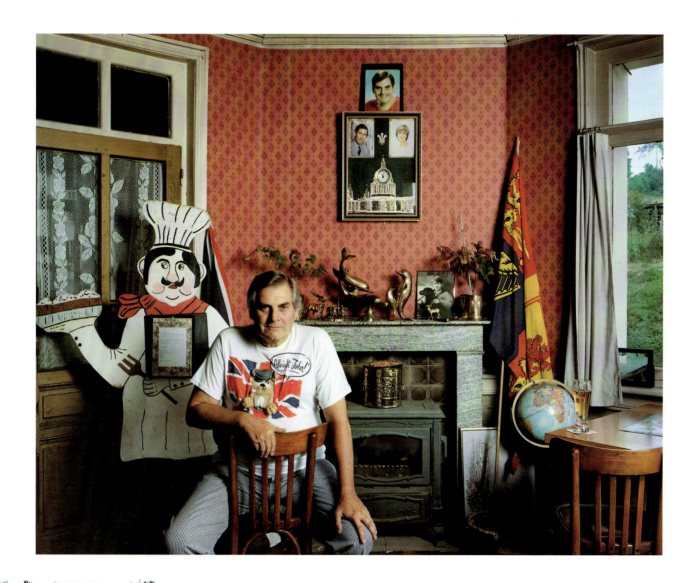

Publican
Peter Dolphin
Bar Dolphin
Enquin-sur-Baillons

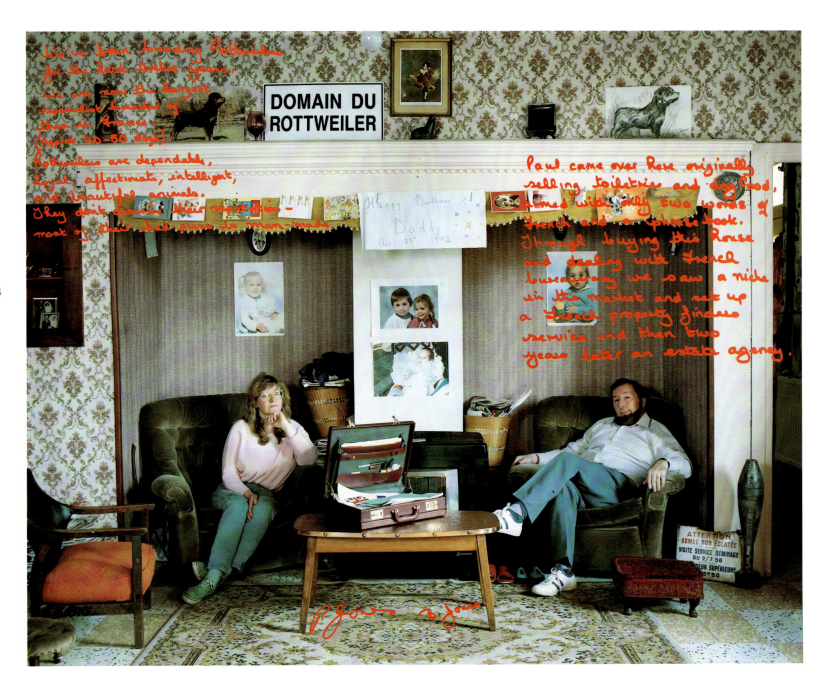

We've been breeding Rottweilers
for the last twelve years.
We are now the largest
specialist breeder of
them in France.
(approx 40-50 dogs)

Rottweilers are dependable,
loyal, affectionate, intelligent,
and beautiful animals.
They don't deserve their reputation -
most of their bad press is man-made.

DOMAIN DU
ROTTWEILER

Happy Birthday
Daddy
April 23rd 1992

Paul came over here originally
selling toiletries and dog food,
armed with only two words of
French and a phrase book.
Through buying this house
and dealing with French
bureaucracy we saw a niche
in the market and set up
a French property finders
service and then two
years later an estate agency.

P. Jones J. Jones

Estate agents and rottweiler breeders
Paul and Janet Jones
Setques

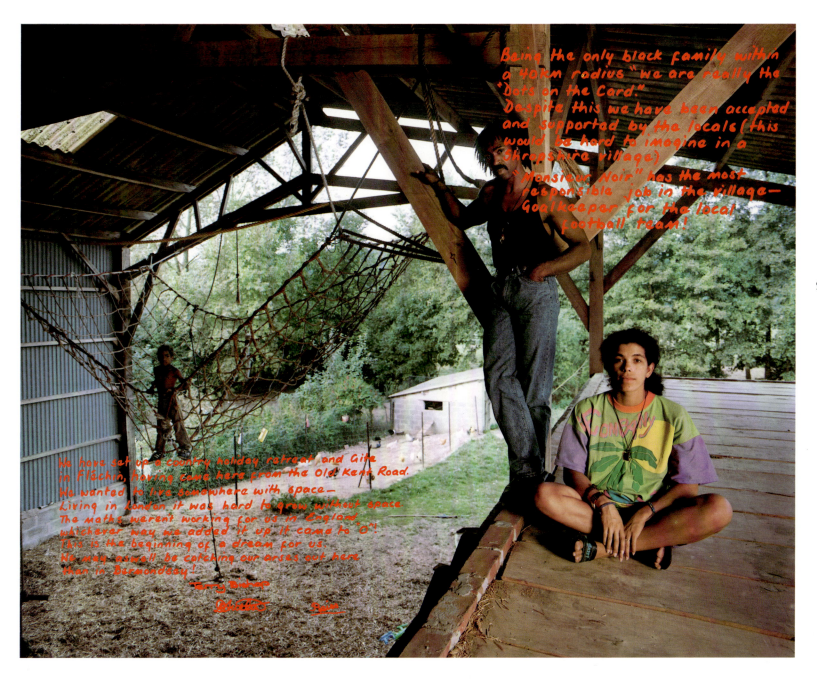

Being the only black family within a 40km radius "we are really the "Dots on the Card."
Despite this we have been accepted and supported by the locals (this would be hard to imagine in a Shropshire village)
"Monsieur Noir" has the most responsible job in the village — Goalkeeper for the local football team!

We have set up a country holiday retreat, and Gite in Fléchin, having come here from the Old Kent Road.
We wanted to live somewhere with space —
Living in London it was hard to grow without space
The maths werent working for us in England, whichever way we added it up it came to "0"!
This is the beginning of a dream for us.
We may aswell be catching our arses out here than in Bermondsey!
— Terry Bishop
Danielle
Reuben

Gite and activity centre owners
Terry and Danielle Bishop
Flechin

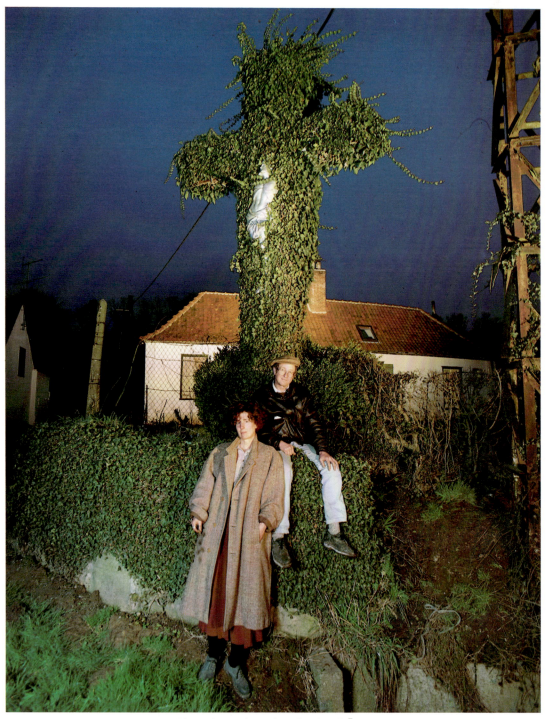

Film-makers Judy Marle and Nick Gifford
St Remy au Bois

KAREN KNORR

The Virtues and the Delights
1991-92

Sapere Aude.
Have Courage to use your own understanding:
that is the motto of the Enlightenment.

Immanuel Kant in answer to the question
'What is enlightenment?' 1794

The Virtues and the Delights refers to the coexistence of the
intellectual and the sensual; polemics, conflict and debate between
men and women. It celebrates the friendships and collaborations of a
group of French and British free-thinkers in the 18th century; Burke,
Paine, Wollstonecraft, Condorcet, Voltaire believed that the virtues of
freedom, liberty, religious tolerance and equality were the natural
rights of every person.

As an unfinished project the Enlightenment promotes the secular
principle of human perfectibility, where human beings are affirmed as
agents in determining their own independence and futures. Feminism
retains the emancipatory tradition and refutes the doctrinaire
interpretation of the 'Age of Reason' as based on eternal truths reliant
on conventional views of human nature. In fact, early feminists such
as Wollstonecraft took issue with the patriarchal underpinnings of the
Enlightenment, demanding a vital place for women in setting the
agenda for life in the 'Cities of the Future.'

The work, made up of photographs taken in Geneva, France and
London is bilingual to emphasise the common heritage of France and
England in shaping hopes for an egalitarian and better future.

Karen Knorr

Caption translations:

99
The Rights of Man

100
Newton's Apple

101
Thoughts in the Mind of God

102
Reveries of a Solitary Walker

104
The Other's Gaze

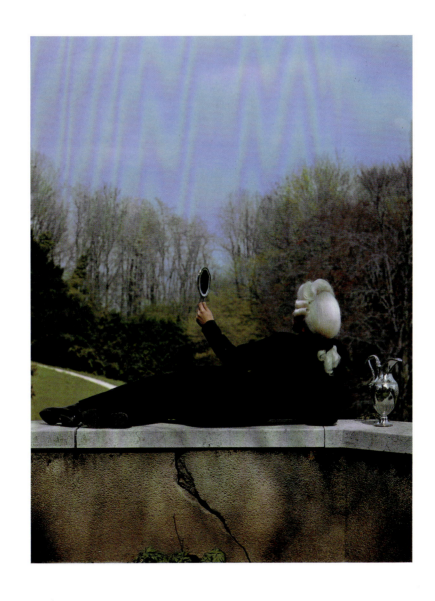

LES DROITS DE L'HOMME

*A Vindication
of the Rights of Men*
1790
Mary Wollstonecraft

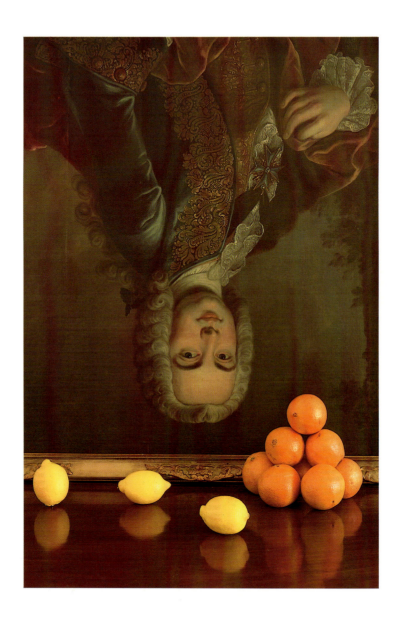

LA POMME DE NEWTON

The Age of Reason
1794-96
Thomas Paine

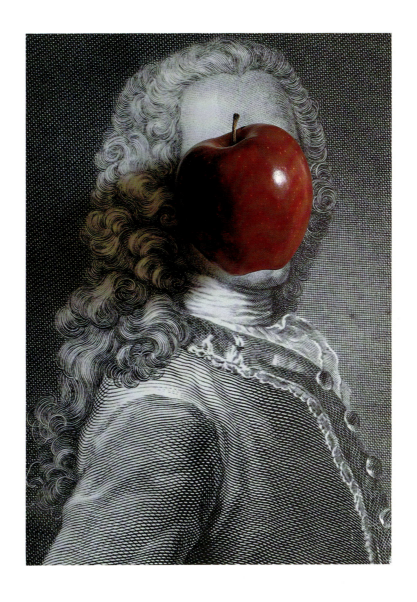

PENSÉES DANS L'ESPRIT DE DIEU

The Ingénue
1776
Voltaire

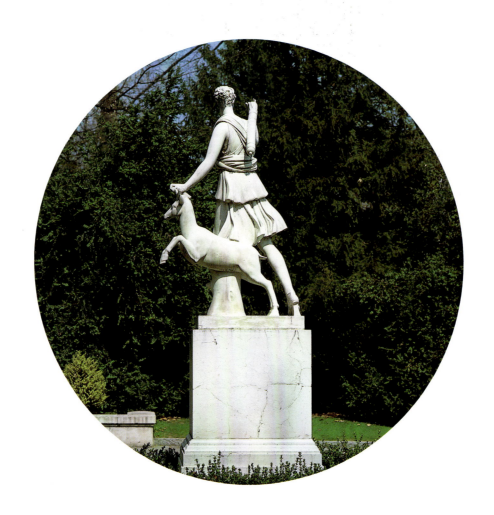

RÊVERIES D'UNE PROMENEUSE SOLITAIRE

Discourse on Happiness
1747
Emilie du Châtelet

IF VIRTUE, TO DESERVE THE NAME
MUST BE FOUNDED ON KNOWLEDGE,
LET US ENDEAVOUR TO STRENGTHEN
OUR MINDS BY REFLECTION
UNTIL OUR HEADS BECOME
A BALANCE FOR OUR HEARTS.

Mary Wollstonecraft
A Vindication of the Rights of Woman

OUR HOPES FOR THE FUTURE OF THE HUMAN SPECIES
CAN BE REDUCED TO THREE IMPORTANT POINTS:
THE DESTRUCTION OF INEQUALITY BETWEEN NATIONS;
THE PROGRESSION OF EQUALITY FOR ALL PEOPLE AND,
FINALLY, THE IMPROVEMENT OF MAN AND WOMANKIND.

Marie Jean Caritat, Marquis de Condorcet
Sketch for an Historical Picture

104

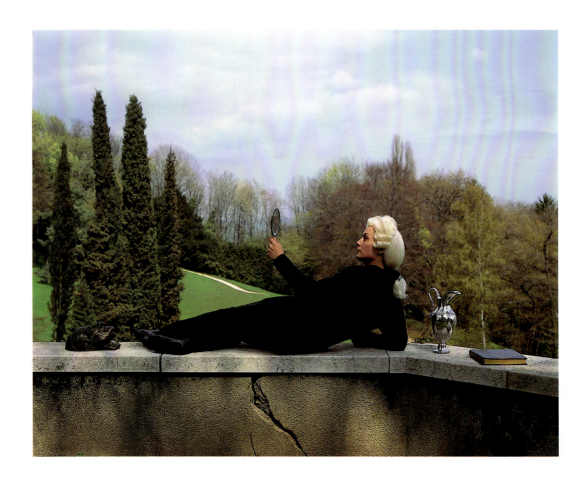

LE REGARD DE L'AUTRE

A Vindication of the Rights of Woman
1782
Mary Wollstonecraft

NOTES ON CONTRIBUTORS

Kenneth Baird specialises in the practice of aerial photography, and teaches photography and the history of photography at the University of Michigan where he was appointed Professor in 1982. During the past ten years he has undertaken interdisciplinary photographic research projects in Europe, the United States and the Pacific. Awarded a Guggenheim Fellowship in Photography in 1983–84 to document the US/Mexican border from the air, he has also received major commissions and awards in England and the United States, where his photography has been widely exhibited and is included in many permanent collections.

Born in England, Baird returns regularly to record the changing textures of European coastal regions and, more recently, has been exploring the rich history and culture of New Mexico.

Simone Canetty-Clarke lives in London where she studied at the London College of Printing. Her work is much in demand by advertising and television companies and has been published in numerous newspapers and magazines.

Canetty-Clarke's work for the CCPM is a development on a commission of largely landscape photographs she undertook as part of the *South Downs Photographic Survey* (1988).

Huw Davies lives with his family in the northeast of England where he teaches Photography at the University of Sunderland. He is currently developing and researching a major project on prisons and surveillance.

Davies studied at Trent and Manchester Polytechnics. His previous exhibitions and publications have included *Unwatched Operations* (1986), *Transitions* (1987) and *A Place in the Country* (1990). Since the mid-1980s he has been a partner in Cliffhanger Films and has co-directed several documentaries which have been shown on network television in the UK, mainland Europe and the USA.

As with *A Place in the Country*, Davies collaborated with writer, Nigel Duckers, on his work for the CCPM in the Pas de Calais. He prefers to get to know the people he photographs, producing 'constructed portraits' in which they seem quite at ease. *Home from Home* uses written annotations from the subjects to literally overlay the image with added meaning.

Anna Fox studied at West Surrey College of Art and has worked as a photographer since 1986. Her photographs have been exhibited widely in Britain, the rest of Europe and beyond. *Workstations*, her first major project was published by *Camerawork* in 1988. She currently lives in North London with her family and juggles the demands of being a mother with two young children, lecturing part-time at Kent Institute of Art and Design and working on her second book *Weekend Wargames*.

The Village was inspired by a long family connection with country life and an awareness that 'it's not what it seems.' Her grandmother still lives in Compton and it is where her mother spent her teenage years.

Julian Germain studied at Trent Polytechnic and the Royal College of Art. He now lives in County Durham where he lectures part-time at the University of Sunderland.

Germain's work has been widely exhibited in Britain and abroad. He is best known for two bodies of work: *Steel Works* (1990), an exhibition and publication that explores the ex-steel town of Consett, which sets his own photographs alongside archival images and texts; and *In Soccer Wonderland* (1992) shown at The Photographers' Gallery, London and currently touring. His work has often been used in national magazines and on television, and is included in a number of major collections.

He is currently working on a book of *In Soccer Wonderland* and photographing, amongst other subjects, Mr Charles Snelling, an elderly gentleman who lives in Portsmouth.

Malcolm Glover studied documentary photography at Newport College of Art and the Royal College of Art and now lives in South London. He has exhibited widely in England and Wales and is currently working on an independent project looking at physical and psychological barriers. He teaches photography in various colleges in the South East.

When his work for the CCPM was undertaken Malcolm Glover lived in Brighton and the commission offered a welcome opportunity to document the people and places around him.

Peter Kennard studied at the Byam Shaw School of Art, the Slade and the Royal College of Art and now lives with his family in North East London. Best known for his photomontages with a left-wing message, he has been widely exhibited in Britain and abroad, as well as having had his work published in books, newspapers and journals. Despite his political stance he has been exhibited by one of London's leading independent commercial galleries, Gimpel Fils.

Major exhibitions have included *Images for Disarmament* (1981) ICA, London and Arnolfini, Bristol; *Despatches from an Unofficial War Artist* (1982-3) County Hall, London and toured; *Images for the End of the Century* (1990) Gimpel Fils; Imperial War Museum, London and Fruitmarket Gallery, Edinburgh. Publications of his own include *Keep London out of the Killing Ground*, (1983); *Target London* (1985) and *Images for the End of the Century* (1990).

Karen Knorr is well known for her series of constructed images and texts which explore issues around culture, society and identity. These include *Belgravia* (1980), *Gentlemen* (1983), *Country Life* (1984-85), *Marks of Distinction* (1991) and *Capital* (1991). She has exhibited widely in Britain and abroad and her work is included in a number of major collections.

Knorr studied at Derbyshire College of Higher Education and the Central London Polytechnic. She now lives in London with her husband and young son and is about to take up a post as Course Leader of Postgraduate Studies in Photography at the University of Derby.

Patrick Sutherland is a documentary photographer best known for his environmental work. His first project, Wetland, an affectionate description of life in the Somerset Levels, won a literary award in 1987. A harsh and cynical series describing the processes of modern agri-business, which was published in the *Independent Magazine*, won a prize in the 1990 World Press Photo Awards. A recent project about estuaries is due to be published shortly. He has been awarded numerous public photography commissions and works regularly for the national press.

Sutherland currently runs the postgraduate Photojournalism course at The London Institute and lives in East Anglia with his wife and two daughters. His latest project concerns the process of social change in a Tibetan community in the Himalayas.

Paul Trevor was born in London and grew up on a kibbutz in Israel. Back in Britain he spent five years articled to a chartered accountant before becoming involved in photography. He was a founder member of the Half Moon Photography Workshop from 1973-80, co-edited *Camerawork* magazine from 1976-80 and attended the National Film and Television School from 1982-85.

He is the author of *Constant Exposure* (1987), a photographic exploration of media-culture, and co-author of *Survival Programmes* (1982) and *Down Wapping* (1974), both concerned with Britain's inner cities. He received the Commonwealth Photography Award in 1987 and his photographs are held in museum collections in Britain, France and the USA.

Trevor lives in the East End of London and is currently working on a film project.

Janine Wiedel, an American born in New York, has been living and working in England for over twenty years. Her work as a photographer is firmly rooted in the documentary tradition and has been widely exhibited both in this country and abroad. She has had several one-person shows at the Photographers' Gallery, London and elsewhere. Books of her work include *Irish Tinkers* (1976), *Vulcan's Forge* (1979) and *Faces with Voices* (1992). Her work for the CCPM was published in *Dover: A Port in a Storm* (1991).

Wiedel lives in South London with her son. She runs The Photolibrary, a bank of images which she is constantly updating. Her work is used by numerous newspapers, magazines, book publishers and television companies.

Neal Ascherson was born in Edinburgh, studied history at Cambridge, and became a journalist. He has worked for *The Guardian, The Scotsman* and *The Observer*; for six years he was *The Observer's* Central European correspondent, based in Germany, specialising in East European affairs. In 1989 he joined *The Independent on Sunday* as a columnist. He has written two books about recent Polish history and a collection of his columns and essays, *Games with Shadows*, was published by Radius in 1988. He lives in North London and is currently completing a book about the Black Sea area.

COMMISSIONS

Centre Régional de la Photographie Nord Pas-de-Calais
Mission Photographique Transmanche

1

Bernard Plossu / Michel Butor: *Paris–Londres–Paris*

2

John Davies / Michael Kempf: *Autoroute A26–Calais–Reims*

3

Philippe Lesage: *Chantier du lien fixe transmanche: terminal*

4

Jean-Louis Garnell: *Chantier de percement du tunnel sous la Manche*

5

Martin Parr: *One day trip*

6

Josef Koudelka

7

Dityvon: *Canal du Nord*

8

Jacques Vilet / Michèle Vilet: *Escaut Source Océan*

9

Lewis Baltz: *Ronde de Nuit*

10

Bernard Plossu, Jean-Christophe Bailly: *Route Nationale 1*

11

Tim Brennan: *Fortress Europe*

12

Olivo Barbieri: *Frontière Franco-Belge*